Vincent van Gogh

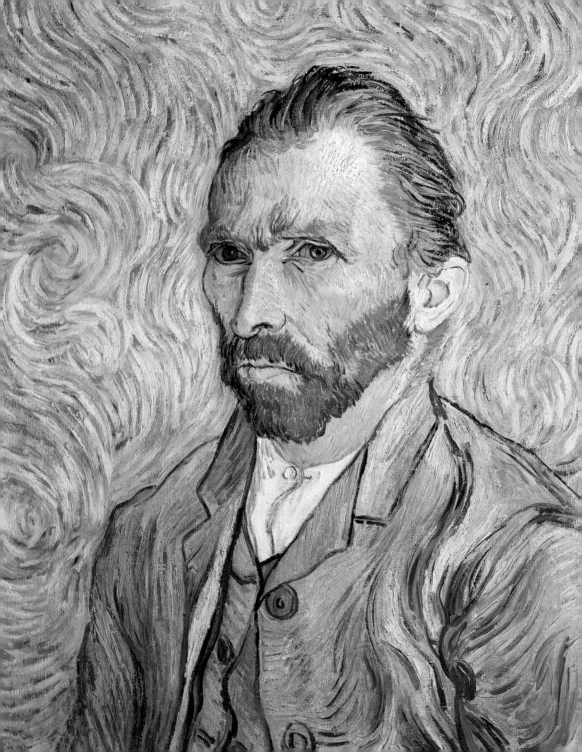

Vincent van Gogh

Life and Work

Dieter Beaujean

BARNES
&NOBLE
BOOKS
NEW YORK

The Search for Meaning
page 6

The Budding Artist
page 14

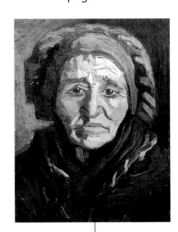

March 1853

August 1880

June 1888

October 1888

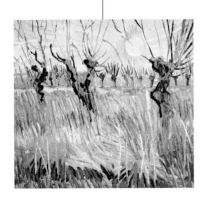

A Time of Light
page 50

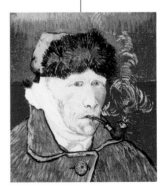

Art and Utopia
page 58

Apprenticeship in Paris
page 26

In Provence
page 40

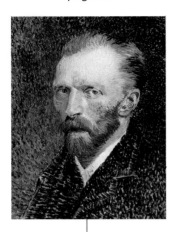

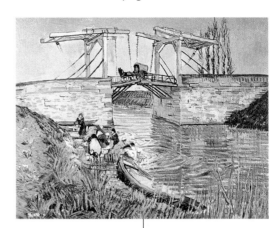

March 1886

February 1888

May 1889

June 1890

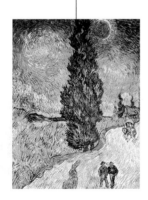

Saint-Rémy
page 68

Auvers-sur-Oise
page 82

Life's Meaning

1853–1880

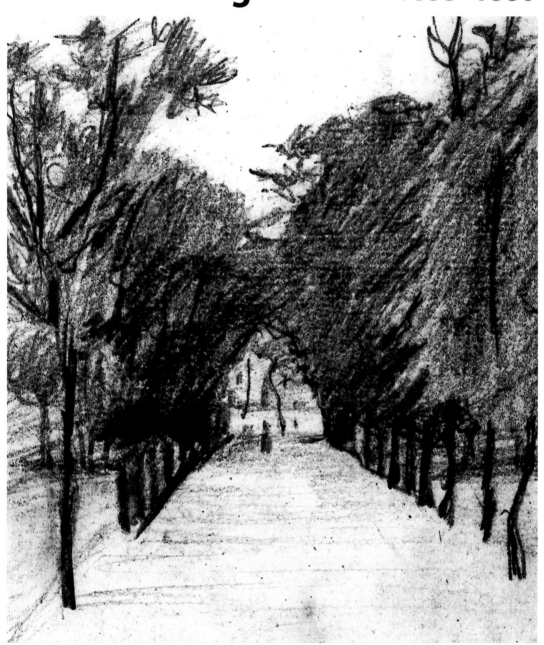

Although Vincent van Gogh worked as an artist for only 10 years or so, he is one of the best-known artists today. Part of his fame is due to his unusual life, which fostered all kinds of myth. The huge variety of jobs he held testify eloquently to his unyielding search for unknown goals, for a meaning to life. The painter who sold only one painting in his entire life and yet whose works today command record sums, was also an art dealer in The Hague, London, and Paris, a supply teacher in Ramsgate, and a Methodist minister's assistant in Middlesex, England. He worked as a bookseller in Dordrecht, embarked on theological studies in Amsterdam and was subsequently a preacher in La Borinage in Belgium for nearly two years. There, among the miners, he began to draw, purposeful at last: in their midst, the change from evangelist to artist took place, in an environment of oppressive poverty. The empathy with want and wretchedness and his restless endeavor remained characteristic of van Gogh's entire life.

Charles Darwin, photo ca. 1875

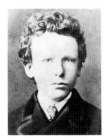

Vincent van Gogh at 13

1853 Second Empire proclaimed in France by Napoleon III.

1859 Darwin's principal work *On the Origin of Species* is published.

1867 World Exposition takes place in Paris.

1868 The sale of Luxemburg to France provokes conflict between the Dutch crown and Parliament.

1871 Paris Commune. William I is crowned German emperor in the Hall of Mirrors in Versailles.

1878 William Booth founds Salvation Army in London.

1853 Vincent Willem van Gogh born in Groot-Zundert, North Brabant, Holland.

1869 Vincent begins training as an art dealer in The Hague.

1873 Vincent is sent to the London branch.

1874 Vincent moved to head office in Paris.

1876 Dismissed as an art dealer, Vincent goes to London to become a supply teacher.

1878 Vincent becomes a missionary among the coal miners of La Borinage in Belgium.

1879 Vincent is again dismissed from office, this time as a preacher.

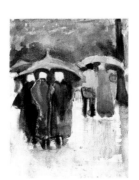

Opposite:
The Long Walk (Avenue), 1874 (detail),
A drawing from the third sketchbook for Betsy Teersteg, Rijksmuseum Vincent van Gogh, Amsterdam

Right:
In the Rain, ca. 1880
Watercolors on parchment paper, Gemeentemuseum, The Hague

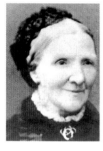

Anna Cornelia van Gogh, née Carbentus, photo ca. 1900

This photo of Vincent's mother was taken in 1900, 10 years after the premature death of her son.

The Presbytery in Zundert, photo

The house belonged to the Reformed Church in Zundert from 1621 until it was demolished in 1903.

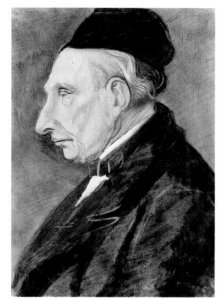

Theodorus van Gogh, 1881
Pencil and ink
33 x 25 cm
Privately owned, The Hague

The portrait of Vincent's father dates from 1881, during the months when Vincent was living in his parents' home in Etten. As a consequence of the son's emancipation and the father's loss of authority, their relationship in Etten was mostly overshadowed by quarrels. Vincent complained of this in several letters to his brother Theo. In the end he was forced to leave his parents' house. For this head and shoulders portrait of his father, van Gogh chose a profile view and very narrow section. The nose is very close to the frame and the minister's cap is cut short.

Childhood in Brabant

Vincent Willem van Gogh was born on March 30, 1853 in the Dutch village of Groot-Zundert, North Brabant. He was given the Christian names of a brother who had been stillborn exactly to the day a year before. The van Gogh family can be traced back to the 16th century. The males were mostly artists or pastors who belonged to the Groningen Party, a liberal branch of the Dutch Reformed Church. Vincent's father Theodorus, a minister, was considered austere, a "small Protestant Pope," while the mother, Anna Cornelia, daughter of court bookbinder Carbentus in The Hague, was said to have a "moving humanity."

Vincent spent his whole childhood in the province of North Brabant, in southern Holland. The typical scenery in the area was flat cornfields and extensive tracts of sandy heath, where he roamed with delight. Later in life, the artist constantly lamented increasing industrialization and the massive intrusion made by agriculture into nature. Vincent's father had a small parish in Zundert, a village about 20 miles from the Flemish metropolis of Antwerp, and this was also where, from 1860, Vincent went to the village school. In it, approximately 200 pupils were taught by just one teacher, a Catholic. Although the school's results were never a matter of complaint, in the fall of 1861 their father took Vincent

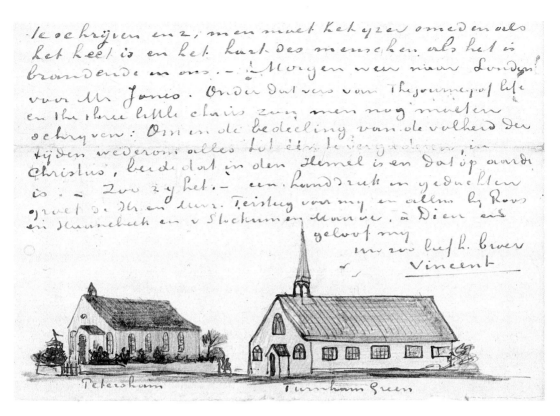

*le schrijven enz, men moet het yzer smeden als
het heet is en het hart des menschen, als het is
brandende in ons. — 'Morgen weer naar Londen!
voor Mr Jones. Onder Dat vers van The journey of life
en the three little chairs zou men nog moeten
schrijven: Om in de bedeeling van de volheid der
tijden wederom alles tot één te vergaderen in
Christus, beide dat in den Hemel is en Dat op aarde
is. — Zoo zy het. — een handdruk in gedachten
groet de Heer en Mev. Teirstey van my en allen by Roos
en Stockum en v Stockum en Maurve, à Dieu en
geloof my
uw zoo liefh. broer
Vincent*

and his sister Anna away and had them taught privately by a governess. In October 1864, he was sent to a boarding school 20 miles away. The separation from his family must have affected him severely, because he recalled the distress of his departure even as an adult. After completing elementary school in the summer of 1866, Vincent went to the recently opened middle school in Tilburg. His drawing teacher, who encouraged him to study systematically, was Constantijn C. Huysmans, who had studied art in Antwerp and Paris and had had considerable success there. Less than two years later, in March 1868, Vincent left middle school prematurely. These last 15 months in his parents' house in Zundert was spent in the solitary study of nature. He increasingly regarded nature as a personal refuge, where he felt secure – his childhood does not seem to have remained in his memory as untroubled. He recalled to his brother Theo later: "My youth was gloomy and cold and barren..."

Small Church, 1876
Pen drawing, from a letter to Theo Jese, November 25, 1876
46 x 21 cm
Rijksmuseum Vincent van Gogh, Amsterdam

In a letter to Theo dated 1876, van Gogh sketched the church in Middlesex where he preached and gave Bible classes. For this simple exterior view with minimal landscape detail, he made no attempt at artistry.

Art Dealer, Preacher or Artist?

Vincent's Uncle "Cent" had built up a considerable art dealer business in The Hague, which since 1858 had been a branch of the Parisian firm Goupil & Cie. On his uncle's recommendation, in July 1869 young Vincent went to The Hague to start learning the business of art-dealing. Here he became familiar with the styles currently fashionable in the salons, but also learned to appreciate the landscapes of the Barbizon and Hague schools. After completing his training, he was moved to the London branch, but an unrequited first love, increasing isolation and his solace in religion, which even his father felt moved to condemn, led father and uncle to decide – even though he was already of age – he should go to the head office in Paris. He became increasingly cantankerous, finding the treatment of art as a commodity distasteful, and in the end his hostility toward customers became intolerable in an

View in the sales rooms of the Hague branch of the Parisian art dealer Goupil & Cie., photo

The sales rooms of Galerie Goupil & Cie. fascinated Vincent as a young trainee with their Victorian opulence and elegance.

art firm of international repute. It was agreed that he should go, and on April 1, 1876 his time as an art dealer ended.

For the 23-year-old Vincent, giving up work he had never really taken to did not mean real liberation. He took refuge in an ever more profound religious devotion, which he felt was his vocation. Unpaid jobs in England first as a supply teacher in Ramsgate and an assistant to a Methodist minister in Isleworth, Middlesex, generated the desire "henceforth to preach the gospel everywhere." At Christmas, he returned to his parents' home, and for six months worked as a

Pit 7 of Marcasse Colliery, photo

The contrast between the rich metropolis of Amsterdam and the impoverished coal-mining region of La Borinage on the French-Belgian border must have seemed stark to van Gogh. He often observed the miners, such as those in Pit 7 of Marcasse Colliery in Wasmes, with its typical colliery buildings and mountainous slag heap.

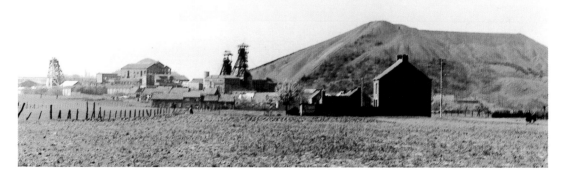

Miners in the Snow on the Way to the Pit, 1880
Colored drawing
44.5 x 56 cm
Rijksmuseum Kröller-Müller, Otterlo

Vincent sent a sketch of miners on the way to the pit in a letter to Theo in 1880. A short while later he repeated the subject with few alterations as a large pencil drawing with a color wash. In the foreground, men and women trudge through the snow with downcast gaze. Their attitudes and faces indicate the hopelessness of their lives. The pit buildings and winding wheels in the background indicate the destination of the arduous march. The general absence of overlapping planes, sharp separation of foreground and background by hedges, and the monotonous array of figures indicate van Gogh's early period as an artist, which began here in the coalmines of La Borinage. He was well aware of his untrained graphic style, and told Theo of his exercises copying artists such as Millet.

bookseller in Dordrecht. The family had decided to put Vincent's religious vocation on a solid footing and, with the help of relatives, to send him to university in Amsterdam. He studied for the entrance exam to the Theology faculty, but after a year had to give up. To his disappointment, he failed to pass a three-month course at a missionary school in Brussels, and he returned to his parents convinced he was a total failure.

A job as a preacher in La Borinage seemed to be a way out of his dilemma. Van Gogh's fanatical compassion, his compulsion toward self-sacrifice to the point of self-flagellation and his attempts to live like a latter-day Christ – without

possessions – like the pitmen, led to conflict with the church authorities and finally to his dismissal on the grounds of "undermining the dignity of the priesthood." He remained in La Borinage for another year as a self-appointed evangelist, but his missionary zeal had given way to an interest in the everyday affairs of people. He recorded his observations in drawings, which now gained a new status in his otherwise dismal existence. The former art dealer and preacher had gradually found a sense of direction. The systematic attention to drawing was a foretaste of his decade as an artist.

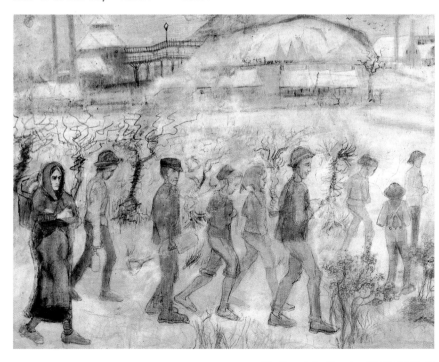

The Brothers Theo and Vincent

"More than anything that Theo did for his brother, perhaps nothing bears witness to greater self-sacrifice than enduring living with him for two years."

<div align="right">Johanna van Gogh-Bonger, 1913</div>

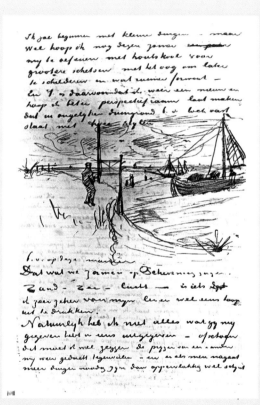

A page of a letter from Vincent van Gogh to his brother Theo, (August 5 1882), Rijksmuseum Vincent van Gogh, Amsterdam

Van Gogh kept in touch with only two of his three siblings all his life: his sister Wilhelmina and above all his brother Theo. The 600 or so surviving letters to Theo are a comprehensive testimony to the life and work of a forerunner of modern painting. Written almost like a diary, they contained not only everyday and biographical matter but also opinions on his own art and the art situation in general. Some also contain small sketches, which were there so Theo could share in the artist's life. In the summer of 1872, the brothers seem to have been emotionally very close. Fifteen-year-old Theo had visited his brother in The Hague, to familiarize himself with conditions in the art trade as a possible future career. With his brother growing up, Vincent was glad to have a friend with whom he could discuss all his interests. To judge from later letters, a walk down the road to Rijswijk was a particularly formative experience. Though four years younger, Theo always seems to have been a kind of alter ego for the artist. Vincent's letters document more than one attempt by him to mold his younger brother according to his own ideas, for example expressly recommending that Theo read certain books or telling him to skip others.

Theo indeed chose the same career as his brother and started training at the Galerie Goupil in Brussels, later taking up a permanent position in Goupil's Paris branch. Working in the art trade enabled Theo to provide his elder brother with regular financial support. Yet he also advised Vincent to make his artistic output more market-oriented. Theo encouraged his brother to dedicate himself to oil painting and agreed to bear the costs of this.

In Nuenen, Vincent arranged with Theo to give all his paintings to his younger brother in return for the monthly payments, so that "I can see it as money that I have earned."

The house at 54, rue Lepic in Paris, where Vincent lived as a tenant of Theo's, photo

Now and then Vincent complained from Nuenen about Theo's cautious and apparently critical comments and declared that Theo was not doing enough to find buyers. The letters suggest that the relationship between the brothers was often less than cordial, particularly where money was involved. Theo's timid attempts to stem the outflow of money plunged Vincent into profound anxiety. At such times he wrote his brother begging, sometimes even despotic, letters complaining of his wretchedness.

Finally, after long and persistent urging, in March 1886 Vincent came to Paris, the center of modern art, against his brother's advice and without his knowledge. There, thanks to Theo's contacts, he got to know numerous artists who had a decisive influence on his art and with whom he struck up friendships.
Theo and Vincent shared a flat for only two years. The brothers could live fulfilled

Vincent van Gogh at 18, during his time as an apprentice at the art dealers Goupil & Cie. in The Hague, photo

lives neither with nor without each other, and Theo died only seven months after Vincent, whom he had supported to the last at the cost of great personal privation.

Theodorus van Gogh, younger brother of Vincent van Gogh, ca. 1889, photo

The Budding Artist 1880–1886

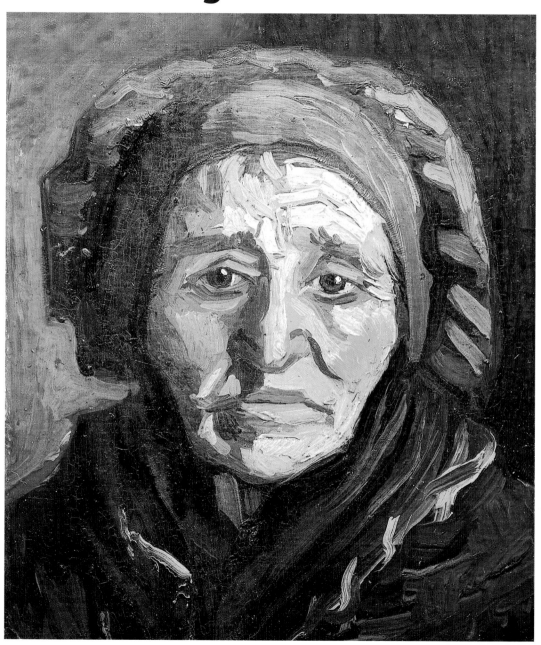

Van Gogh set about his aim to become a painter with great resolution and seriousness. Essentially, he taught himself the techniques, but followed tradition by schooling himself on old masters, studying principally Jean-Françoise Millet and his pupil Israel. He sought professional help at art school in Brussels, and later, when he set up his own studio, the aid of his cousin Anton Mauve, a leading representative of The Hague School. From the fall of 1885, he also went to the art school in Antwerp. These courses were particularly helpful for their guided practice and life classes. Despite all the copying, his approach was from the first highly idiosyncratic. At the same time, he had a striking preference for modest subject matter, such as that he found in his bare native landscape, the common places of the poor or the simplest of objects. His palette was chiefly notable for its dark brown tones, his drawings for their thick, heavy hatchings in deep black.

Cologne Cathedral, woodcut, 1880

1880 Paris Communards are granted amnesty.

1880 Cologne Cathedral finished (begun 1248, chancel consecrated 1322, completed 1842–1880).

1882 John D. Rockefeller founds the Standard Oil Trust in New York, an amalgamation of 40 oil companies.

1884 Germany places its settlements in SW Africa under imperial protection, thus creating the first German colony.

Van Gogh's view of Amsterdam, 1885

1880 Vincent begins art course at the Academy in Brussels.

1881 Back from Brussels to Holland. Van Gogh returns to his parents' home in Etten.

1882 Vincent moves into a flat in The Hague with the prostitute Sien.

1883 After breaking with Sien, van Gogh goes back to Drenthe.

1884 Vincent stays at his parents' house in Nuenen.

1885 Vincent's father dies. Vincent embarks on an art course in Antwerp.

Opposite:
Head of a Peasant Woman in a Greenish Bonnet, 1885 (detail)
Oil on canvas, 38 x 28.5 cm
Rijksmuseum Kröller-Müller, Otterlo

Right:
Mining Women, 1882
Watercolors with white highlights,
32 x 50 cm
Gemeentemuseum, The Hague

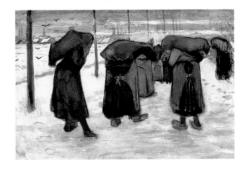

First Steps – Brussels, Etten, The Hague

Adriana Vos-Striker (Kee) with her son, photo ca. 1880

Crouching boy, 1881
Black crayon and watercolors
47 x 61 cm
Rijksmuseum Kröller-Müller, Otterlo

This sensitive drawing with prominent outlines, worked in delicate watercolor tones, dates from Vincent's autumn in Etten. It shows mastery of human proportions and well-caught characterization.

After the inadequacies of his life as a preacher, van Gogh hoped to impress his family by choosing an "artist's" career. With the same enthusiasm he had manifested in beginning his vocation as an evangelist, he now plunged into his new ambition.

In autumn 1880, he moved to Brussels, and after the horrific deprivations of the La Borinage mines he enjoyed the everyday benefits of the city. His intention had been to improve his skills in the studio of the distinguished Dutch painter Willem Roeloff (1822–1897), whom Theo had recommended. Despite his deep-rooted aversion to academies as such, he was persuaded by Roeloff to attend life and plaster-cast classes at the Royal Academy of Art. He went to anatomy seminars and told his brother he had done studies of a skeleton. He learnt the rules of proportion, perspective, light and shade, "which you have to know just to be able to draw the least thing." He made friends with the painter Anthon van Rappard and was able to use his studio.

When his friend left Brussels, van Gogh had to look for new rooms, and he decided to live in the country for a while. In April 1881, the family had decided that Vincent should live with his parents in Etten. He accepted the offer, as it benefited him, and got down to work drawing. Subjects were mainly neighbors at work, always outside in good weather; otherwise he would work on existing canvases indoors.

In the summer of 1881, van Gogh fell in love with his widowed cousin Kee Vos, who was visiting Etten with her son, but unfortunately the feeling was not returned. His importunate attitude toward Kee and increasing distaste for his father's opinions inevitably led to conflict with his family, which at Christmas 1881 culminated in his father showing him the door.

The move to The Hague brought far-reaching personal changes such as an intermittent cohabitation with a one-time prostitute, Sien, and the consequent ostracism by his acquaintances, and also changes in his art. His cousin by marriage, the

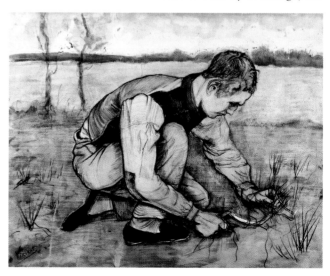

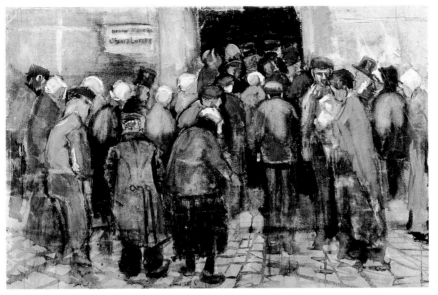

The State Lottery, 1882
Watercolor
38 x 57 cm
Rijksmuseum Vincent van Gogh, Amsterdam

This watercolor from fall 1882 was done in The Hague.
It shows people who have scrimped to find a few pence for the lottery tickets. The figures crowd silently into the open doorway, depicted in brown flecked with hesitant color highlights to make a telling composition. Significantly, the artist's own description for this picture of scarcely fulfillable hopes was "The Poor and Money."

painter Anton Mauve, had encouraged van Gogh to draw more from live models again and to start painting, and his Uncle Cent had given him a box of watercolor paints with which to do it.

But his Hague period was more notable for the development of his drawing style. Whereas hitherto he had been anxious to reproduce what he saw as naturalistically and "correctly" as possible, in The Hague the emphasis on feeling emerged increasingly in the subject matter he chose. Initially just studies of isolated figures, his drawings gradually turned into highly appealing small narratives whose subject matter covered both figurative and emotional interconnections in equal measure.

Sien with Cigar at the Stove, 1882
Pencil, black crayon, pen, 45.5 x 47 cm
Rijksmuseum Kröller-Müller, Otterlo

The pregnant woman sitting on the floor holding a cigar is an unusual but poignantly drawn subject.

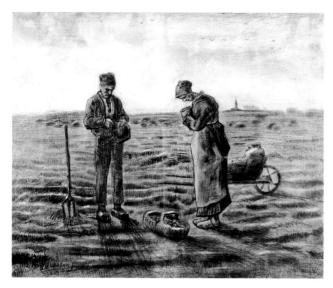

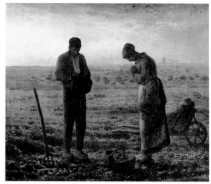

**The Vesper Bell
(after Millet)**, 1880
Colored drawing
47 x 62 cm
Rijksmuseum Kröller-
Müller, Otterlo

Jean-Françoise Millet
The Vesper Bell
1857-1859
Oil on canvas
56 x 66 cm
Musée d'Orsay, Paris

A peasant couple in the field harvesting potatoes have stopped work and stand in devout prayer in a landscape of flat fields and meadow. A church is visible in the distance. Deftly used pencil, ink, and watercolors depict the late afternoon light, with long shadows and incipient twilight. The drawing was not a field study but a studio copy of Millet's most successful picture, which fetched a record price when sold and had been reproduced in several printed versions.

Van Gogh's Realism

In art, realism means an artistic representation that imitates reality or tallies with reality. Realistic art professes to depict the phenomena of everyday life as it finds it. In van Gogh's first years as an artist, he attempted to reproduce reality in as great a detail as possible. He wrote to his parents: "Only if I set about drawing thoroughly and seriously and try to reproduce reality will I get anywhere ..."

He equated the ability to draw realistically with social recognition and consequently with the best career prospects. In fact, during this period he was constantly striving to improve his drawing technique down to the last detail.

Yet he soon found that technical dexterity or mere depiction no longer satisfied him. "If only I could express what I feel," he wrote to Theo. What he sought was greater power of expression in representing his simple subject matter: compassion and indictment were his themes when he showed men and women at their everyday work or at rest and sunk in melancholy. Penury, simple people, their unbroken piety, the modest objects of their lives and their landscapes were pictorial subjects that he explored not just in these first days as an artist.

Typical of the early period of creation, however, was the assimilation of his color palette to the simple tones of his subject matter – earthy tones, often exaggerated into dark brown, and a chiaroscuro derived from his teacher Mauve, displaying tone gradations without bright colors.

The same desire for greater expression applied to his drawing style, as he paid scant attention to

Weaver in Front of an Open Window, 1884
Oil on canvas
67.7 x 93.2 cm
Neue Pinakothek, Bayerische Staatsgemäldesammlung, Munich

A diagonal view of the corner of the room with the loom illustrates the weaver's imprisonment in his cottage labor. Through the window we can see a peasant woman in front of the ruined medieval tower of Nuenen. The contrast of the dark interior and daylight reflected on the cloth in the loom reinforces the barren existence.

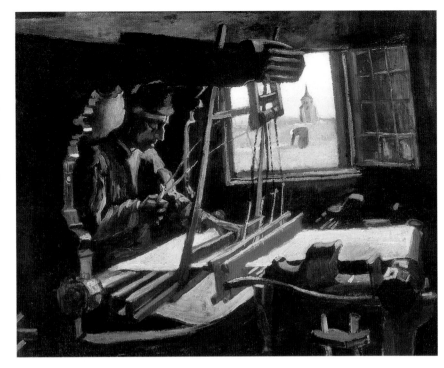

Sketches, 1883
Pen drawing in Letter to Theo
Rijksmuseum Vincent van Gogh, Amsterdam

Artist Max Liebermann had already worked in the Dutch province of Drenthe, which impressed van Gogh in respect of his own drawings. The figurative and landscape subjects are impressively recorded in very confined areas. The clear articulation is reinforced by vigorous and varied hatching done with a pen.

outlines and placed great emphasis on volume, mass, and living depth. Again and again he started studies based on living models. He had neighbors pose for him, or watched them at work. His simple way of life, always dependent financially on others, was decisive in establishing a profound empathy with his models.

The "Peasant Painter" of Nuenen

In December 1883, van Gogh left the solitude of Drenthe and moved in with his parents in Nuenen, remaining there until November 1885. His father had been transferred to the parish north-east of Eindhoven. A makeshift studio was set up for Vincent in the laundry room, where there was also a bed for him. The warm welcome from his parents was soon overlaid with bad-tempered

Seated Peasant Woman, 1884
Drawing
30 x 20.5 cm
Rijksmuseum Vincent van Gogh, Amsterdam

Drawings from live models were also used by van Gogh for his paintings.

talk about the non-conforming and peculiar life of their artist son. Only his mother's accident and the subsequent need to look after her made the subject peripheral for a while. At his mother's sickbed, van Gogh got to know the neighbor's daughter, Margot Begemann, the only woman in his life who ever fell in love with him. Unfortunately, her plans to marry the eccentric Vincent were attacked by her family so violently that she tried to poison herself. Vincent complained to his brother about her parents' lack of understanding of his interests.

After his father died in March 1885 and inheritance disputes arose between his mother and his sisters, he left the manse and found a studio at the Catholic sexton's house.

Despite the seclusion of Brabant, corresponding with Theo and reading art periodicals kept him fully abreast of developments in the art world. His chief interest was color theory, which he endeavored to put to use in his work. In portraits, for example, he tried out surprising juxtapositions of red and green. Although they did not correspond to the real colors of peasant faces, their recurrence in nature was intended as a representation of the link between man and nature. Irrespective of the particular genre concerned, the emphasis was not on realistic reproduction but rather on how he felt about the subject. Van Gogh's preference for simple rural people is particularly characteristic of his work in Nuenen.

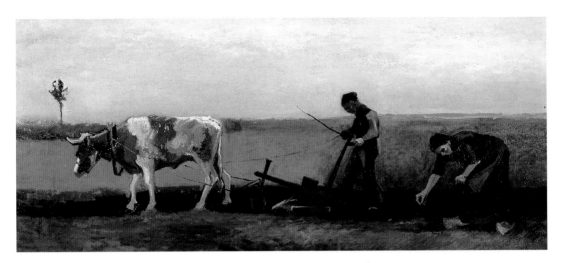

Setting Potatoes,
1884
Oil on canvas
70.5 x 170 cm
Van der Heydt
Museum, Wuppertal

A commission for a set of six pictures for a dining room was the occasion for this picture. An ox pulling a plow steered by a peasant followed by a woman setting the potatoes proceeds like a procession from right to left across the foreground. Horizontal lines articulate the landscape format, whose prominent contours are pierced only by the peasants and a single tree. A bold streak of orange sunlight on the right horizon gives the finishing touch to an atmospheric, aesthetic picture.

Along with genre scenes – minor episodes of everyday life – his favorite subject here was portraits of peasants. Though portraits had hitherto been commissioned works, showing mainly bourgeois sitters in aristocratic poses wearing their Sunday best, Vincent's innovation was to adapt the form to show individuality directly and unsparingly. He paid the models, choosing them for their individual characters. Only when the local minister had forbidden members of his flock to pose did van Gogh go over to painting still lifes.

Peasant House, 1885
Oil on canvas
60 x 85 cm
Staedelsches
Kunstinstitut und
Städtische Galerie,
Frankfurt

Figures, house, and landscape are blended in earthy tones and relieved with highlights. The brushwork ranges from the very delicate to the very thick, indicating the artist's ability to apply paint in different ways.

The Potato Eaters

Really, it seems to me art stands too high to merit such carefree treatment.

Anthon van Rappard (painter and friend of van Gogh),
on the *Potato Eaters*

The Potato Eaters was a summary of all van Gogh's painting in Nuenen so far. It was at once the epitome of his figurative, still life, and interior paintings. Three women and two men sit round a table in a low-ceilinged hut with tea cups and a bowl of potatoes in front of them. A paraffin lamp hung on the beam above them casts a feeble light in the evening twilight. Van Gogh has dispensed with lines or features strictly parallel to the frame, yet the figures relate to one another according to a rigid geometrical pattern. Two people shown in profile frame the couple sitting frontally opposite us, the latter being separated by a figure sitting with her back to us on this side. The few actions shown focus solely on the meager meal, the faces look serious and sad, the attitudes indicate dejection. A clock and a small painting of the Crucifixion on the left and shelves with kitchen utensils on the right wall represent the scant furnishings.

In this picture of peasant life, van Gogh experimented with new color combinations that went beyond simple depiction to reflect the painter's own seriousness and feeling as well. Areas initially planned as white were in the end rendered in a dull gray made up of red, blue, and yellow, with the faces like "dusty potatoes, not peeled of course." A certain emphasis on the hands was intentional and was meant to indicate the link between their manual labor and eating the potatoes. Van Gogh spent a lot of time on the subject, and several drawings and oil studies have been preserved. He repainted the first heads executed in detail over and over again, finally applying the finished work in rough, rapid brushstrokes so that the spontaneous appearance of the painting should convey an impression of naturalness. The critical reception of this painting ranged from cautious approval to rank rejection, for example by van Rappard, which led to a breach between the two painters.

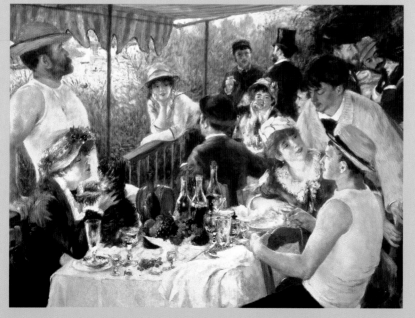

Auguste Renoir
The Rowers at Breakfast, 1881 (detail)
Oil on canvas
130 x 175 cm
The Phillips Collection, Washington

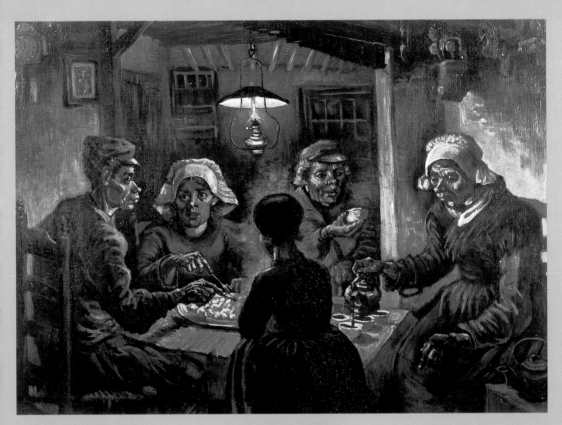

Unlike in Renoir's *The Rowers at Breakfast* of 1881, where the act of eating as such was not involved and some of the figures even have their backs to the table, van Gogh's meal represents not a social occasion but the simple life of peasants. The rough brush technique and dark, earthy palette were the appropriate means of expression for this first masterpiece.

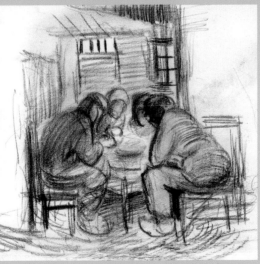

The Potato Eaters, 1885
Oil on canvas
81.5 x 114.5 cm
Rijksmuseum Vincent van Gogh, Amsterdam

Peasants at a Meal, 1885
(Detail) Crayon study
42 x 34.5 cm
Rijksmuseum Vincent van Gogh, Amsterdam

The Potato Eaters **23**

Quay in Antwerp with Ships, 1885
Oil on canvas
20.5 x 27 cm
Rijksmuseum Vincent van Gogh, Amsterdam

This view of the Scheldt quayside and distant city was done in Antwerp in December 1885. Van Gogh had happened to be there during a cloudburst and had been taken by the rich variety of subject matter and its direct environment. In particular, the silhouettes of the ships against the departing rainclouds and the people moving about in front of them seem to have taken his fancy. The blurred outlines of the figures and their reflections in the flickering shadows catch the combination of weather and movement very strikingly. Thick horizontal streaks of color with marked edges are strung together closely to indicate the street damp with rain. Individual flecks of paint representing white bonnets create women walking along the murky road. Dark tones predominate in the painting, but the overall earthiness of earlier pictures is now lightened with red, white, and yellow.

At Art School in Antwerp

The death of his father in 1885 and subsequent breach with his family, together with rumors of an illegitimate child and notice to quit his studio, forced van Gogh to leave Nuenen. In November he arrived in Antwerp, moved into a room in the house of a paint dealer and roamed the city eagerly looking for new subject matter. He visited museums, refreshed his acquaintance with old masters, and studied the paintings of the master of the Flemish baroque, Peter Paul Rubens. It was particularly Rubens' handling of color that awoke van Gogh's interest. In bad weather he worked in his room, which he had decorated with colored Japanese woodcuts – presumably this was his first intensive contact with Japanese art, which was so important for his further development as an artist. Occasionally, he sought to work with live models, but the cost was too great for systematic study. Finally, he applied to the director of the Antwerp Art Academy and was accepted for a course of painting and drawing classes.

In his letters to Theo, he justified this step on the grounds of better working conditions, but the work at the academy was not plain sailing. The old-fashioned teaching methods

and his unconventional drawing style led to constant discontent on both sides. Unfortunately, hardly any drawings from the Antwerp period have survived. Van Gogh's stay in the metropolis on the Scheldt was marked particularly by a chronic shortage of money and efforts to survive by extending the range of his output, for example by doing city views for tourists. The consequence of his workaholic lifestyle was emaciation and illness. He tried and failed to sell peasant pictures from Nuenen, although the dark colors now even bothered the artist himself. For his new paintings he selected much lighter colors, bought more expensive brushes so he could apply paint more delicately, and attempted to emulate Rubens by bringing out emotion through combinations of color.

Peter Paul Rubens
Marquesa Brigida Spinola Doria,
1606 (Detail)
Oil on canvas
152.5 x 98.7 cm
National Gallery, Washington

Presumably van Gogh was not able to study the structure of this female portrait in the original, but saw a lithography by Pierre-Fréderic Lehnert done after 1848, which apparently belonged to his collection of graphics.

Portrait of a Girl,
1885
Oil on canvas
60 x 50 cm
Alfred Wyler Collection, New York

Vincent van Gogh engaged a model from an Antwerp café for this study for a painting. The artist's choice of lighter colors compared with his work in Nuenen is particularly evident in such portraits. For this head and shoulders profile portrait, he used a matt white for the blouse, applied quickly in thick brushstrokes. To do the girl's head, he reduced the vigor of the brushstroke, applying emphasis with strong red highlights. Apart from the gleaming coloring of the lips and hairband, he used a muted red for the facial color, having noted its power to articulate and express in Rubens' work.

In spring 1886, Vincent arrived in the art metropolis of Paris and moved in with his brother Theo. He went to Fernand Cormon's art school, where he became acquainted with Henri de Toulouse-Lautrec and, later, Émile Bernard, who remained a lifelong friend. In June, Vincent and Theo moved to the district of Montmartre, where Vincent set up a studio. Due to Theo's position in the art business, Vincent met the Impressionists, whom he learnt to appreciate in due course and used extensively as a model for his own work. He made friends with Paul Gauguin, painting with him in the open air, went to Asnières with Bernard and put on a joint exhibition with Anquetin, Bernard, Gauguin, and Toulouse-Lautrec in the Café au Tambourin. The mass of impressions of the city and the constant talk of art had a lasting influence on van Gogh, rounding off the long years of training, from which he emerged as one of the most important artists in modern art.

Poster for Otello by Giuseppe Verdi

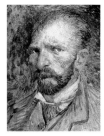

Self-portrait, 1887

1886 The conservative Boulanger is appointed Minister of War in France. Wagner's operas receive a rapturous reception in Paris.

1887 Giuseppe Verdi's opera, Otello, premièred.

1886 Vincent goes to Paris and moves in with his brother. Attends Cormon's painting classes.

1887 Joint exhibition with Bernard, Gauguin and Toulouse-Lautrec. Van Gogh paints in the open air. The acquaintance with Gauguin develops into friendship.

Opposite:
Self-portrait, 1887 (detail)
Oil on card, 41 x 32.5 cm
The Art Institute of Chicago, Chicago

Right:
Fernand Cormon's salon in Paris,
photo

Paris, photo

The photo shows the Rue Lepic in the Parisian district of Montmartre towards the end of the 19th century. A few months after Vincent's surprise arrival in the city, his brother Theo rented a flat big enough for both of them at 54, rue Lepic, where Vincent could set up a bedsit studio. Vincent painted several pictures of the view from his window.

Below:
Fernand Cormon's studio, photo

Though Cormon as a teacher left no deep impression on pupils such as van Gogh, Bernard, Toulouse-Lautrec, and Anquetin, he provided them with opportunities to work from plaster casts and live models, and he represented a tolerant work environment, among other things encouraging pupils to paint in the open air.

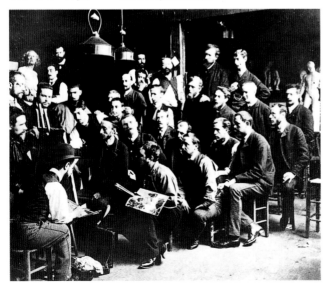

Arrival in Paris

In January and February 1886, van Gogh wrote to his brother Theo ever more insistently that he wanted to move to Paris and go to the studio of the history painter Fernand Cormon (1845–1924). Theo consented, but asked his brother to wait until he had a larger apartment. Without taking any notice of this request, the artist left Antwerp in March and only told Theo of his arrival in Paris when he was there. Until a suitable apartment had been found in Montmartre where Vincent could set up a bedsit studio, both of them lived in Theo's small apartment in the rue Laval.

For Vincent, Paris represented the "home of pictures," where he would find good contacts with dealers and fellow painters, but above all a better financial set-up through Theo and the road back to good health after the strains of Antwerp. For four months, he attended Fernand Cormon's art school. Cormon was a very tolerant teacher, who even encouraged his pupils to do open-air painting, otherwise frowned on by academy painters. At Cormon's, Vincent (as he insisted everyone call him) once again had an opportunity to work from plaster casts and live models, as if it were in continuation of his academy studies in Antwerp. At the same time, he made friends with his fellow students, particularly Henri de Toulouse-Lautrec, Anquetin, and later Bernard. Bernard had come to the school as a 16-year-old

and been expelled after "coloring" a studio curtain.

With his usual all-or-nothing approach, van Gogh initially concentrated on his drawing, but under Cormon's guidance he also practiced painting in oils, using as subject matter existing work in the studio and freely chosen topics such as city views. Soon after his arrival in Paris, van Gogh had taken part in the usual exchange of pictures. The practice of swapping paintings, also with artists outside Paris, was a passion of his that apparently dates back to this time.

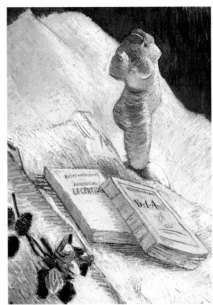

Still Life with Plaster Torso, Roses and Books, 1887
Oil on canvas
55 x 46.5 cm
Rijksmuseum Kröller-Müller, Otterlo

View over Paris from Montmartre, 1886
Oil on canvas
38.5 x 61.5 cm
Öffentliche Kunstsammlung, Kunstmuseum Basel

Van Gogh painted the view from Montmartre several times. The painting shown is one of the most successful pictures of the series.

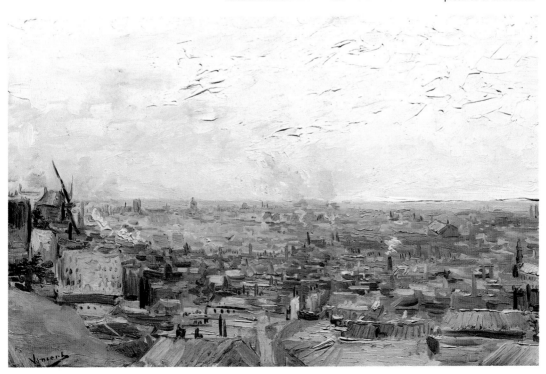

Encounter with Impressionism

During van Gogh's time in Paris, every progressive artist called himself an Impressionist. The term originally came from Claude Monet's painting *Impression, Sunrise*, shown in 1874 in a group exhibition. The title was used by critics as a term of abuse for this group of artists, who, dissatisfied with the development of art in their day, turned against the academies and took it on themselves to reinvigorate art. What they really sought was the perfect reproduction of reality, and they thus, in fact stood firmly in the tradition of their trade. Colors and form should be painted as we see them, not as we learn with our rational minds to depict them. Dissolving firm outlines, capturing gleaming light, and the coloration of shadow are the achievements of the Impressionists. They no longer mixed paints on the palette but placed them in small dots or streaks on the canvas. Only in the eye of the beholder was this application of paint to come together as an impressive representation.

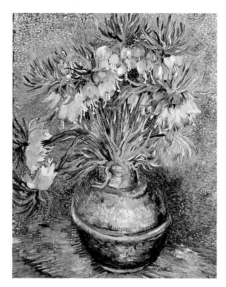

Crown Imperials in a Copper Vase, 1887
Oil on canvas
73.5 x 60.5 cm
Musée d'Orsay, Paris

In April or May 1887, van Gogh painted a bunch of crown imperials in a bulbous copper vase that is still to be found in the van Gogh Museum in Amsterdam. A perfect complementary color contrast of orange blossoms in front of a blue background and a skillfully varied application of color are what distinguish this still life. In Vincent's own words, this was an attempt to "reproduce intensive color, not a gray harmony."

Trees and Undergrowth, 1887
Oil on canvas
46.5 x 55.5 cm
Rijksmuseum Vincent van Gogh, Amsterdam

In this slightly landscape-format picture, van Gogh recreated Impressionism in his own individual style. An initially confusing interplay of green and yellow dabs of paint soon resolves into an impressive experience of nature. Slender tree trunks with long brushstrokes in purple are surrounded by almost impenetrable masses of green leaves, on which yellow sunlight is reflected. The position of the purple streaks and the yellow and green dots of color break the picture into a foreground with flat bushes in front of a closely packed line of trees, behind which the midday sun is reflected.

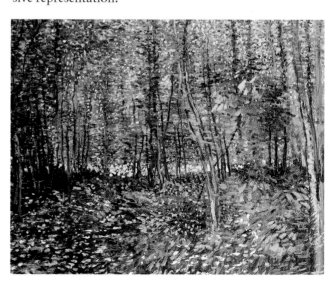

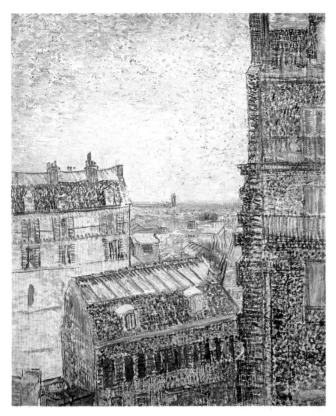

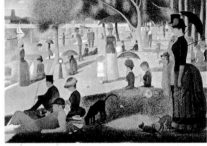

Georges Seurat
A Sunday afternoon on the Ile de la Grande Jatte, 1885
Oil on canvas
206 x 306 cm
The Art Institute of Chicago, Chicago

Seurat prepared his painting intensively with 62 sketches, and exhibited it in May 1886 at the eighth Impressionist salon in Paris. It was soon elevated to the status of a manifesto of Neo-Impressionism.

La Grande Jatte is a promontory in the Seine that was a popular rendezvous place for elegant Parisians, whom Seurat represented with rigid, doll-like figures in shimmering sunlight and a grid technique of colored dots, as the culmination of pointilliste techniques. For van Gogh, this painting was certainly a contrast to his own technique.

View of Paris from Vincent's Room in the rue Lepic, 1887
Oil on canvas
46 x 38 cm
Rijksmuseum Vincent van Gogh, Amsterdam

In this hazy sunlit view from his window, van Gogh combined his own traditional method of working, outlining contours as in a drawing, with modern pointilliste application of paint in small dots for the surfaces.

Despite its celebration of bourgeois life, the style made a great impression on van Gogh and, as Theo dealt in Impressionist pictures, it was easy for him to establish personal contact with the big names of the style. Vincent admired especially Edgar Degas' nudes and Claude Monet's landscapes, but the most marked influence was that of the Neo-Impressionists, including Georges Seurat. Seurat's pointillisme was a quasi-scientific development of Impressionism, and consisted of a very dense application of minute dots, to enhance the intensity of the colors. In Paris, van Gogh adopted the new painting technique and experimented with it in all genres of picture. However, from the first he tried to go beyond Impressionist techniques in attempting to put across his feelings as color effects. Stringing together brushstrokes he compared these with "words in a speech or a letter."

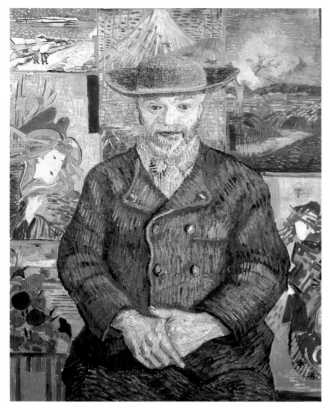

Tanguy, the Paint Dealer

Numerous civil and worker uprisings marked the political situation in France in the 19th century, but it is the Paris Commune of 1871 with its temporary worker government that perhaps features largest in the history books. Van Gogh's paint dealer Julien Tanguy had lived through the failure of the revolution and been arrested as a communard. Père Tanguy, as he was called, now put his ideas of a better world into effect

Portrait of Père Tanguy, 1887
Oil on canvas
92 x 75 cm
Musée Rodin, Paris

Van Gogh painted his fatherly friend full frontally, with vigorous and strikingly varied brushstrokes, in front of a background of virtuoso coloration in Japanese woodcuts.

through a special philanthropy that particularly benefited young artists.

In the rooms of his shop, which was not far from the rue Lepic, he had set up a small gallery in which works of Paul Cézanne, Paul Gauguin, Vincent van Gogh, and Georges Seurat were first seen at the same time.

Tanguy's shop was likewise a favorite meeting place of artists, where van Gogh and Émile Bernard got to know each other better and became friends. Whether van Gogh ever met Paul Cézanne personally at Tanguy's remains uncertain, but it was there that he saw Cezanne's pictures of Aix-en-Provence, which conveyed to him his first artistic impressions of Provence. Bernard often invited van Gogh to Asnières, a small place on the Seine north of Paris. Here van Gogh painted a number of Impressionist pictures. Paul Signac, who had likewise painted in Asnières, wrote of the brief day trips: "We painted on the river embankments, ate in an inn at midday and returned to Paris on foot down the Avenue de St.-Ouen or the Avenue de Clichy."

Around this time, van Gogh developed his own style from pointilliste techniques, applying pure colors rapidly in broad strokes. The palette appears initially happy and sunny, but at a second glance is enriched by a darker blue and brown. Touches of strong color link people or objects to the background. Borrowings from the colored Japanese woodcuts in his brother's collection are represented

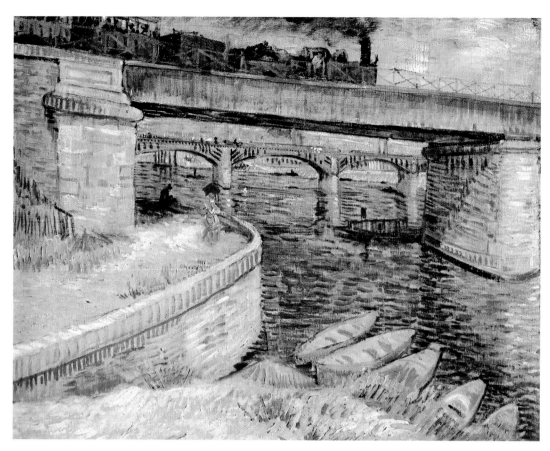

either as picture-within-a-picture quotations or taken over as an experience of bold color effects. Overall, van Gogh's years of "apprenticeship" seem to come to an end with the portraits of Père Tanguy in 1887.

Seine Bridge near Asnières, 1887
Oil on canvas
32 x 40.5 cm
Rijksmuseum Vincent van Gogh, Amsterdam

In this painting, van Gogh was interested in top view, bottom view, and view through, as well as different materials and elements in the smallest of spaces. In his view of the Seine bridge, van Gogh included the curve of the bank in the picture which, combined with the rowboats and oblique view of the moving train, adds up to a perceptible diagonal movement. The pastose application of the water, made up of thick, closely strung brushstrokes, is so adroitly done that both individual forms and the heat of a summer's day in full sunlight are evident. The repetition of color – for instance in shadows, light reflections on the water or vegetation on the river bank – pulls the picture together. Yet van Gogh's mastery of filigree bridge railings is as great as that of the parasol of the walking woman in red.

Pictures of a City

At the end of the 19th century, Paris presented to interested residents or visitors a multi-faceted picture, notable both for its pleasurable nocturnal activities and numerous cultural offerings. Even today, the pulsating life of the boulevards still exerts a magical attraction. The cafés were particularly popular as meeting places for intellectuals, artists, poets, and those aspiring to become such. Van Gogh himself spent long and pleasurable hours in the boulevard cafés. They were not just places for painters to meet for pleasure – they

Montmartre with Mill and Vegetable Allotments, 1886
Oil on canvas
46 x 38 cm
The Art Gallery and Museum, Glasgow

Van Gogh's views of windmills and vegetable plots on Montmartre in 1886 reminded him of Holland. They are notable for their brighter colors and are the first signs of an unconstrained application of color.

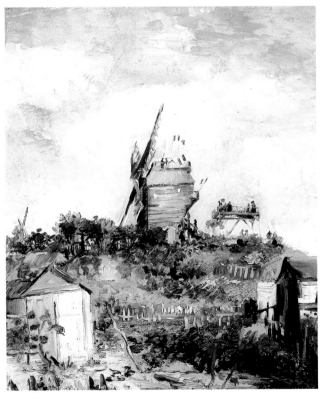

also provided subject matter for paintings. Vincent drank absinthe, met friends or kept a lookout for unusual faces that he could paint. He later recalled that during this last winter in Paris he had almost become a drunk.

The "home of pictures," as van Gogh called Paris, offered young artists excellent opportunities to develop their art outside the academies and to exhibit their work. Comprehensive public art collections, above all the Louvre, displayed the great names of all periods and cultures of the world, and provided a many-sided source of inspiration. For open-air painters like van Gogh, there were parks such as the Jardin du Luxembourg or the Tuileries, which were frequented first and foremost by the wealthy of the city on their Sunday outings, and thus provided a wide variety of fascinating subject matter.

Depicting elegant park saunterers was a new field for van Gogh's painting. The unfamiliarity of the sight and the examples of fellow painters must have been the decisive factors, because in Paris van Gogh otherwise still maintained his preference for everyday scenes of poorer people in their city locations. Numerous painted views of Montmartre with its windmills – which must often have reminded him of Holland – bore names such as the Moulin de la Galette and were surrounded by lush gardens, and were testimony to van

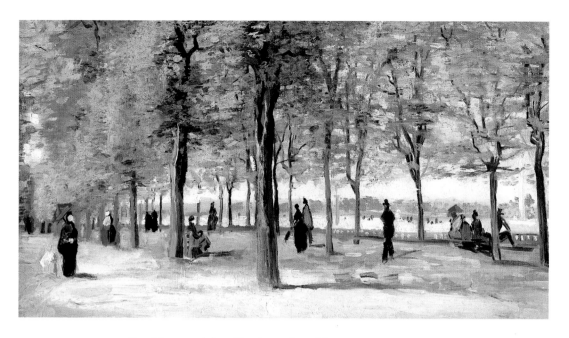

Avenue in the Jardin de Luxembourg,
1886
Oil on canvas
27.5 x 46.1 cm
Sterling and Francine Clark Art Institute, Williamstown (Mass.)

In his first summer in Paris, van Gogh painted this carefree view of Sunday strollers in bright, friendly sunlight. The diagonal avenue separates the pictorial space into three differently lit strips ranged one behind the other, all with few people. Young foliage is contrasted with the red highlights of two parasols.

Gogh's special affection for his homeland even in Paris. The search for subject matter took him out to the suburbs, too, so that we now have what are today unusual views of Paris: taverns with gardens, industrial areas, fields and gardens, hills with quarries or long walk trails. To obtain various things for his everyday life and objects for still lifes, he went to the flea market.

His interest in the landscape of Paris seems to have waned by winter 1887. The light and color range of the metropolis on the Seine seemed no longer adequate. In letters to his sister Wil[helmina], the artist said he would go south, to continue painting there.

A Pair of Shoes, 1886
Oil on canvas
37.5 x 45 cm
Rijksmuseum Vincent van Gogh, Amsterdam

According to his friend Gauzi, van Gogh bought a pair of old but clean and freshly polished coachman's boots in the flea market, but did a study of them only after returning from a walk covered in mud. He himself once said: "Dirty shoes and roses can both be good in the same way."

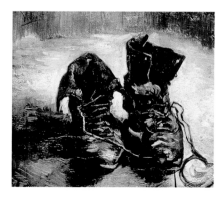

Pictorial Composition in van Gogh

"Perspective is a Latin word," wrote the German Renaissance artist Albrecht Dürer, explaining the term as a way of showing a three-dimensional situation on a flat surface, "and means seeing through it." A drawing that is done in perspective should enable the viewer to recognize actual [spatial] relationships.

In the 16th and 17th centuries, educated artists published pattern books, on the basis of which, with the help of a few guidelines, painters could develop their spatial structures directly on the canvas, without preliminary studies.

Yet it was only the Impressionists who seriously changed the spatial set-up. Atmospheric density was created instead, with space suspended. Inferential information, a central viewpoint, and volume were dispensed with; an evenness of lighting was introduced. Van Gogh often thought he would never fulfill the requirements of an artist's existence, for example when he saw himself as just a painter of figures, a genre traditionally regarded as the most inferior.

The financial limitations of his work situation and inadequate support from his family often left him with the feeling he was being treated "like a large shaggy dog with dirty paws." And yet Vincent van Gogh's innovations were decisive for the following generations, particularly in respect of pictorial composition (page 90).

In The Hague, when he was just starting out, he had constructed himself a simple perspective frame based on Dürer's example and practiced using that. In Paris, he based himself partly on Impressionist experiences, for example the retreating or advancing effect of particular colors, while to some extent he took over the sliding perspective and arbitrary edge overlappings of his Japanese prints, and occasionally he even copied colored woodcuts by Andro Hiroshige.

His unusual angles of vision, a consequence of his fixing objects by means of a perspective framework, and stressing of diagonals are very similar to Japanese perspectives. As in his Asiatic models, an ornamental surface countering the effect of depth allowed the option of either a flat or a

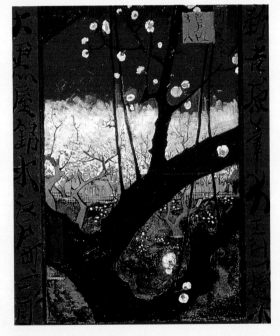

**Plum Trees in Blossom
Outside the Tea House at
Kameido (after Hiroshige)**,
1887
Oil on canvas
55 x 46 cm
Rijksmuseum Vincent van
Gogh, Amsterdam

Andro Hiroshige
**Plum Trees in Blossom
Outside the Tea House at
Kameido**, 1857
Colored woodcut
38 x 25 cm
Rijksmuseum Vincent van
Gogh, Amsterdam

*In my picture of the night café ... I wanted to express the dark power of a bar –
under the cover of Japanese cheerfulness.*

Vincent van Gogh to Theo van Gogh, Arles, September 1888

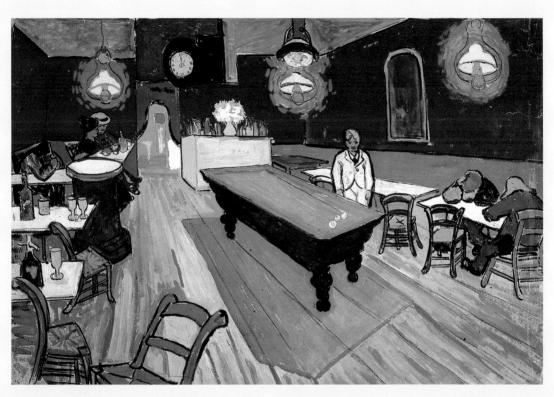

depth-based pictorial structure. An unusual example of a depth-based pictorial composition is the *Night Café* of 1888. Vincent told Theo about his efforts to use red and green to express the terrible human passions of "night owls," the destitute and the inebriated. Besides using color as a medium of emotion, he also constructed an impressive undertow of depth based on perspective, which was intended to illustrate the attractive force of the café. The Café was a place where "you can ruin yourself, go mad and commit crimes." Extremely steep structural lines underlie the bold spatial effect on which the whole pictorial structure is established. The coloration, which looks so spontaneous, was at the same time the result of a carefully considered composition. The effectiveness of this masterpiece derives from a notable combination of planned pictorial structure and rapid execution.

The Night Café, 1888
Watercolor
44.4 x 63.2 cm
H R Hahnloser Collection, Berne

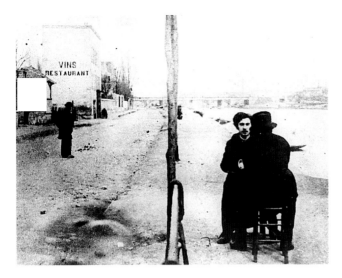

Above:
**Émile Bernard and
Vincent van Gogh
by the Seine bridge**,
photo ca. 1886

**Henri de Toulouse-
Lautrec**, photo
ca. 1890

Paris Avant-garde

In the 19th century, Paris was the center of modern art and in many areas the cradle of the cultural avant-garde. Claude Debussy's orchestral suite *Printemps*, Emile Zola's novels or Auguste Rodin's sculptures such as *The Kiss* or *Burghers of Calais* bear witness to a time that can also offer great names in painting. Vincent van Gogh had become familiar with works of the pioneers of Impressionism such as Claude Monet, Auguste Renoir, and the aging Camille Pissarro, not least through his brother Theo's job at the art dealers Goupil, and he knew Edgar Degas and Pissarro personally. Admittedly their work no longer carried the aura of the youthful avant-garde. They exhibited in the major galleries or the Salons des Indépendants, and were called by van Gogh painters of the "grand boulevard."

The new generation of artists of the petit boulevard, known as the Post-Impressionists among whom van Gogh ranked himself, met at Père Tanguy's or in the Café Tambourin and also exhibited there. Former fellow-pupils of Cormon's and friends such as Henri de Toulouse-Lautrec, Louis Anquetin, and John Russel were augmented by Émile Bernard and Archibald Hartrick. Vincent was introduced by his brother to Paul Gauguin, whose powerful, rhythmic painting he admired but who spent little time in Paris during Vincent's years there. Gauguin came from Brittany and was on the point of setting off to Panama and Martinique in the South Seas, in the meantime devoting himself almost exclusively to pottery. Van Gogh became acquainted with Georges Seurat's pointillisme and La Grande Jatte at the eighth Salon des Impressionistes, and also Seurat's artistic disciple Paul Signac.

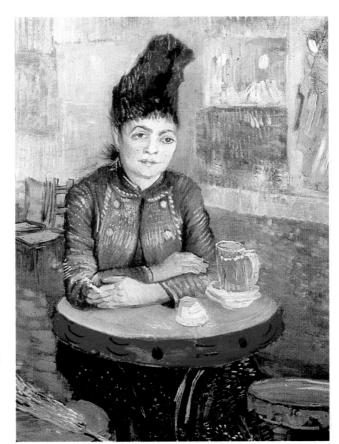

For his own artistic development van Gogh became involved with the Impressionists and Post-Impressionists and experimented with various styles. Pointillisme seems to have interested him only very briefly. The very variety of styles constituted a productive artistic climate in which van Gogh rounded off his years of "apprenticeship" and had a formative influence in helping him to find his own style. Despite all reservations, the group of artists in the "petit boulevard" remained his artistic home. Seurat and Cézanne influenced him through their works, his friends from Cormon days through daily contact as well. Van Gogh's time in Paris was spent as one of a wide circle of friends; there, artistic role models such as Mauve, Toulouse-Lautrec, and Gauguin became colleagues and friends.

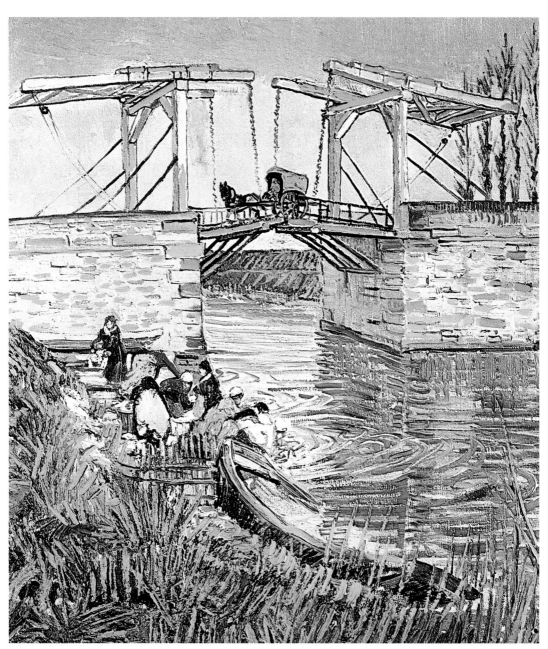

In the fall of 1887, Vincent van Gogh wrote to his sister Wil from Paris signaling his intention to go south for a while: "there's more color there and still more sun." In February 1888, with the assistance of his brother Theo, he set off, bound for Arles. In Paris, van Gogh had boned up on Provence and the simple life, folk costume, rondels, festivals of poetry, and bullfights pictured in Mireille by the Provençal poet Frédéric Mistral and stories by Alphonse Daudet. He arrived in Arles in a snowstorm, and initially painted wintry pictures, then blossoming orchards and flowers, especially sunflowers, simple people including himself, the town, and numerous landscapes: canals with bridges, the banks of the Rhône with its skiffs, and the broad fields of the surrounding countryside. Paul Gauguin visited him in Arles but, following quarrels, the planned artistic community was reduced to just a visit lasting several weeks. Van Gogh was work-obsessed, and created a huge oeuvre – to the point of exhaustion, crises, and finally self-mutilation.

John Dunlop, photo ca. 1888

Self-portrait in a straw hat, 1888

1888 (March) Death of Anton Mauve, the landscape painter whom van Gogh admired so enormously.

The year of the three emperors in Germany.

John Dunlop invents the pneumatic tire for bicycles.

1888 (February) The artist moves to Arles, where he stayed until 1889.

Three pictures by van Gogh exhibited at the Salon des Artistes Indépendants in Paris

Uncle Cent dies.

Van Gogh moves into the Yellow House, which he hopes to turn into an artists' colony.

(June) Van Gogh goes to Saintes-Maries-de-la-Mer.

Opposite: **The Bridge at Langlois in Arles**, 1888 (detail)
Oil on canvas, 54 x 65 cm
Rijksmuseum Kröller-Müller, Otterlo

Right: **On his Way: the Road to Tarascon**, 1888
25.6 x 34.9 cm, pencil and pen
Kunsthaus, Zurich

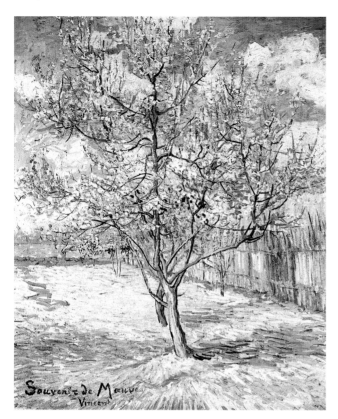

Peach Trees in Blossom (Remembrance of Mauve), 1888
Oil on canvas
73 x 59.5 cm
Rijksmuseum Kröller-Müller, Otterlo

A few weeks after arriving in Arles, van Gogh wrote to his brother Theo: "I'm really hard at it because the trees are in blossom and I wanted to do a Provençal orchard of outrageous colorfulness." He used the transitory state of nature for six paintings of trees in blossom, which he described to Theo in his letters and sketched as a triptych, a winged altar in three parts.

After the death of his former teacher Anton Mauve, van Gogh decided to dedicate the best picture to his revered teacher. In a spontaneous gesture, he told Theo he had called the picture "Souvenir de Mauve, Vincent & Theo", and presented it to the widow. He must have obliterated Theo's name before the paint dried.

In a field painted in purple fenced with a reed fence are two peach trees close together, in the splendor of full pink blossom, which bursts over the whole picture against a cool whitish-blue sky like an explosion, and contrasts with the soft coloration of the fence and garden. As a memorial to Mauve it had to be both colorful and tender at the same time, so as to open the eyes of viewers in Mauve's native town of The Hague to the wonders of this French Impressionist technique. Apart from the memorial, Vincent also documented his own stylistic development: "Probably the best landscape I have ever done," he said in letters to his siblings.

Nature in the Mirror of Art

Plein air (open-air) painting reached its first peak in France before 1850, and left its mark on many subsequent artists. Pacemakers of plein air were the Barbizon School, who revolutionized landscape painting. The colony of artists of the 1930s and 1940s that flourished on the edge of the forest of Fontainebleau not far from Paris had discovered a new, intimate approach to nature. The painters combined the documentary representation of landscape with a subjective impression of light and color to make an atmospheric whole. The Impressionists built on this, breaking up their application of paint into small dots and taking light as their actual trade.

Van Gogh adopted the plein air idea, and was the first major artist to do it in Provence. After the economic successes of the 1860s, the much-lauded "Gateway to the South" had plunged into crisis. Arles had been an important city since antiquity, and consequently it was an architectural treasure chest with outstanding

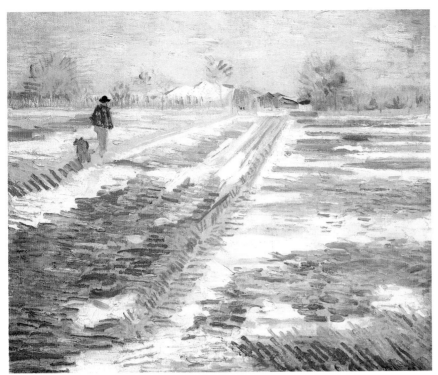

Landscape with Snow, 1888
Oil on canvas
38 x 46 cm
The Salamon
R. Guggenheim
Museum, New York

The snowy landscape was one of van Gogh's first pictures in Arles. Despite the cold, he spent some time painting in the open. Here, the result is an astonishingly bright, sunny picture with a cloudless sky, painted with short, wide brushstrokes applied rapidly to the canvas in white, yellow, green, blue, and brown, and a wonderful red feature on the horizon.

Roman and Romanesque monuments, but these played no part in van Gogh's search for subject matter. Once again, it was the everyday life of simple folk and the expansive fields and meadows of the surrounding countryside that interested him as he roamed through it for days on end. His own experience of nature would be reflected in the colors and forms of his pictures. He wrote to Theo: "I'm seeing new things here, I'm learning, and as long as I'm kind to it, my body doesn't refuse to do its bit either."

Almond Bough in Blossom, in a Jar, 1888
Oil on canvas
24 x 19 cm
Rijksmuseum Vincent van Gogh, Amsterdam

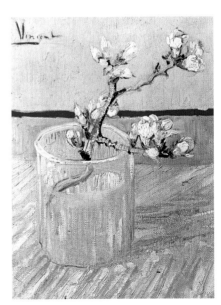

Vincent wrote to Theo about almond trees that were already in blossom even though snow was still on the ground. The still life of a blossoming bough in the jar with the various curves and straights is also a delicate, light studio study of both material and nature.

The Yellow House

After he arrived in Arles, van Gogh lived at first at 30, rue de la Cavalerie, a suburb with an unsavory reputation. The daily expenses of food and accommodation in hotels took up a large part of his monthly budget, which his brother Theo sent him even when in Provence. Finally from May 1, 1888, van Gogh rented one of the many houses that stood empty in Arles and the surrounding vicinity – a consequence of the economic crisis in the region – for a mere 15 francs a month. The house at 2, Place Lamartine, which he often used as a model, stood beside a small shop in the north of the town, opposite the town park. Vincent's new house, which was the yellowwashed half of a double house with a green door and shutters, had four rooms and was whitewashed inside and laid with a red tiled floor.

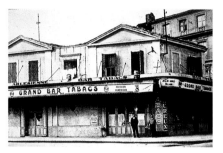

Vincent wrote to Theo the same day about his yellow house "with a lot of sun," in which he wanted to set up a studio. "At last I can see my pictures in a really bright room." But initially van Gogh did not have the money for even basic furniture, so Theo's money for a mattress went to settle old rent debts. The furnishings consisted at first solely of a table, two chairs, and various objects he needed every day. Meanwhile he had to continue sleeping in hotels. Van Gogh had at first postponed getting a bed until winter, but after the death

The Yellow House in Arles, photo

This photo shows the Yellow House after the ground floor was rebuilt as a bar and tobacconist's. Van Gogh rented the right wing, while the left wing contained Crevoulin's grocery store. The house was destroyed by bombs in June 1944 and not rebuilt. The large room on the upper floor served as van Gogh's bedroom and workshop. As in Paris, in inclement weather he painted views from the windows of things close by, such as the butcher's store or the park.

The Yellow House (Vincent's House in Arles), 1888
Oil on canvas
76 x 94 cm
Rijksmuseum Vincent van Gogh, Amsterdam

Vincent painted the Yellow House immediately after moving in (May 1888). In fact, he painted the whole complex of buildings at the street corner so that his own house, the right wing of the double house, is in the middle. All the houses and even the roads are painted in various tones of yellow, which contrast to a hitherto unusual extent with the dark blue of the sky. The diagonal running outwards to the right terminates in a railway bridge in the background, which, with the train traveling towards the left, brings the picture together as a compact whole.

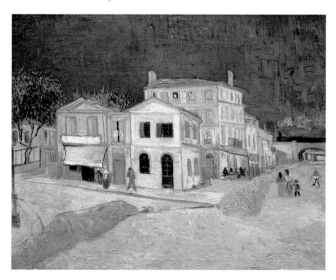

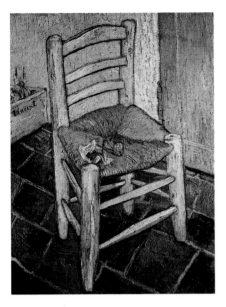

Vincent's Chair with Pipe, 1888
Oil on canvas
93 x 73.5 cm
National Gallery,
London

Van Gogh turned a simple still life into a deft composition of colors, flat areas, obliques, and a confusing jumble of emphatic lines, to make a self-contained, closed picture of a yellow chair and pipe in the corner of the room. In the background is a box with sprouting onions, on which he has written his signature.

lady's room," he enthused in a letter to his brother. He wanted to furnish a room specially for Theo or Paul Gauguin, and decorate the white-washed walls "with lots of large yellow sunflowers." He had asked Gauguin to visit him in Arles for a while. Apparently fellow painters did visit him there, but Gauguin was probably the best-known of these. Nonetheless, he felt increasingly isolated in Provence and tried to make his solitude, his monastic existence as he saw it, tolerable by feverish effort, always in the certainty of overloading body and soul.

of his Uncle Cent, the rich art dealer, he was able to use his legacy to get the house ready to move into in mid-September. The house, the rooms, and even individual objects soon became subjects of paintings, and that is how posterity knows them, since the Yellow House was bombed in the Second World War. Van Gogh decorated his house with pictures, Japanese prints, and above all, portraits which he had in part painted specially for his bedroom, while others came from swaps with fellow artists.

The different views of his bedroom vary principally in the paintings they include. Right from the first, van Gogh did not want to furnish his yellow house in the place Lamartine just for himself: "if someone comes to visit, he must have the prettiest room, ... like a really artistic

Vincent's Bedroom in Arles, 1889
Oil on canvas
72 x 90 cm
Musée d'Orsay, Paris

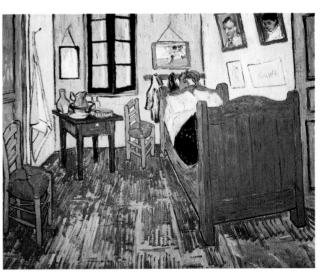

Structure and Contour

Structure, the internal articulation or arrangement of elements into a whole, is a principle of design that occurs particularly clearly in van Gogh's late works. The most minute unit of the pictorial elements that only become a picture combined in a totality is the pointilliste dot. In works by van Gogh such as *The Starlit Night* of 1889, the pictorial elements are bundled together: winding lines become stars in the night sky, sweeps of the brush the tops of cypresses, hatched curves mountain ridges, and geometric shapes the architecture of a place. The sum of all these is a starry night experienced in apparently wild but probably well-thought-out sweeps and brushstrokes of paint.

Contours or outlines are used in emphatically graphic pictures, in order to

The Starlit Night (Cypresses and Village), 1889
Oil on canvas
73 x 192.2 cm
The Metropolitan Museum of Art, New York

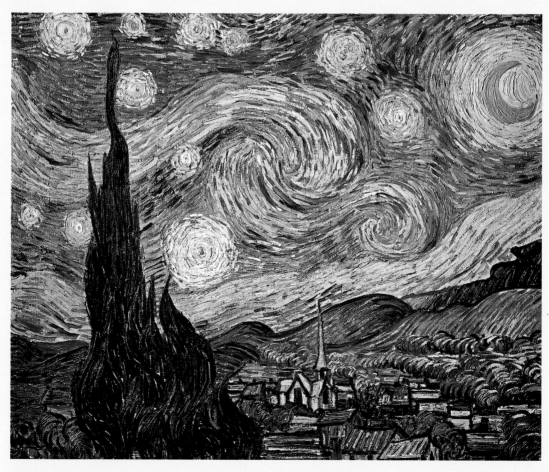

Old Vineyard, 1890
Brush and ink drawing in black and blue on brown paper
43.5 x 54 cm
Rijksmuseum Vincent van Gogh, Amsterdam

in painting appears principally where individual color areas are not modeled but are applied in pure color. Large-area coloration is given form and movement by contour.

Significantly, van Gogh's friends Émile Bernard and Paul Gauguin both claimed to be the inventors of cloisonnism, where areas of flat color are outlined in dark contours.

However, the fact is that Vincent van Gogh used outlines in almost all phases of his work. Particularly the *Dance Hall in Arles*, a painting from 1888 and a synthesis of Bernard's and Gauguin's artistic experiments, documents van Gogh's artistic capabilities using lines. Despite weaknesses in the youthful faces, the picture constitutes a fascinating experience of contour and flat surface. With the bluish-purple brush drawing called the *Old Vineyard*, van Gogh

went beyond the techniques of painting. He placed closed contours behind open contours, so that the balance of the architecture and the dynamic movement of the flora combine in an extremely lively linear picture.

make the internal boundaries of objects clear. In van Gogh's work, they held a key role from the first, and were not limited just to his drawings. Although the Impressionists did without outlines and conceived the pictorial object as countless flecks of color coming together as a whole in the eye of the viewer, van Gogh retained contours even in his Impressionist-style paintings done in his Paris days. He used lines to bind into specific shapes surfaces made up of flecks of bright color. Emphasis on outlines

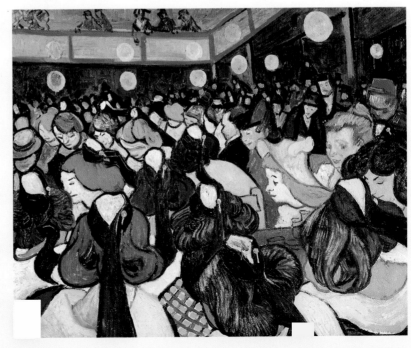

Dance Hall in Arles, 1888
Oil on canvas
65 x 81 cm
Musée d'Orsay, Paris

A Tripper in Saintes-Maries

In June 1888, Vincent van Gogh went on a trip to Les-Saintes-Maries-de-la-Mer, which was called Saintes-Maries for short.

In van Gogh's time, what is now the center of tourism in the Camargue consisted of a market place and a small fishing village, or as Vincent told Theo, "under a hundred houses. The number of bathers varies between 20 and 50." He did the 30 miles from Arles to Saintes-Maries by the regular stage coach, at a reduced price because it was pilgrimage time.

After suffering health problems with his teeth and stomach, van Gogh wanted to spend a week by the sea to recover – he did not go unequipped. In a letter to Theo, he planned to take with him two can-

vases and "everything I need to draw." Despite the worry that it could be too stormy to paint outside, he seems to have taken three canvases for a view of Saintes-Maries and two sea pictures. Van Gogh recorded his stay by the Mediterra-

View Towards Saintes-Maries, 1888
64 x 53 cm
Oil on canvas
Rijksmuseum Kröller-Müller, Otterlo

In his view of Saintes-Maries, Vincent divided a green field into narrow strips by means of purple flowers, presumably lavender, which both distance the viewer and direct his or her gaze. Between field and town a black figure can be made out, indicating a path or road, and thus a

demarcation line. The houses rise behind a wall, dominated by a massive church. A light blue sky spans the whole town creating, with its almost relief-like layer of paint contrasting with the dots and fine brushstrokes of the field and the contoured surfaces of the houses, a multi-layered whole.

Fishing Boats at Sea near Saintes-Maries, 1888
Oil on canvas
44 x 53 cm
Pushkin Museum, Moscow

In a letter written in 1882, van Gogh said he aspired to paint a picture containing sand, sea, and sky in a single picture. It was six years before he painted this unusual sea picture. A high horizon with the fishing boats close to the top edge leave a lot of water area, which van Gogh turned into a choppy sea using pastose brushstrokes. He repeated the subject in three drawings.

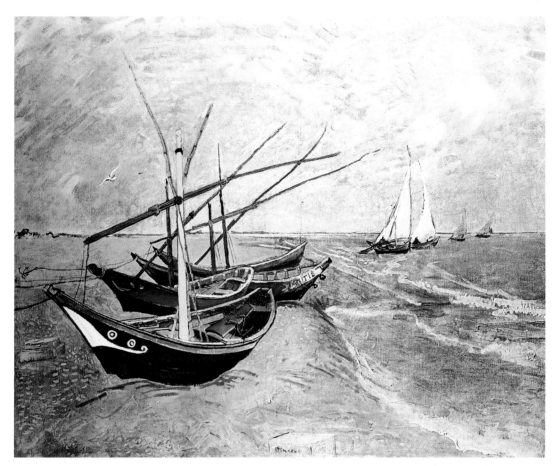

nean mainly in studies done on the shore. The boats pulled up on land were "so pretty in shape and color that one might think of flowers." The straw-thatched huts of the fishermen and salt workers he also drew like those in Drenthe, which he had once called "human nests," probably in contrast to the beaches of the Côte d'Azur, with its luxurious lifestyle. The shore reminded him of Holland, whereas he compared the color of the water with that of mackerel, "i.e. changing, you can't always tell if it's green or violet or blue, because a moment later it gleams pink or gray."

Altogether, the week in Saintes-Maries seems to have confirmed his intention to remain in the south of France because, in the colors of the south, he as a colorist saw the future of a new art.

Fishing Boats on the Shore at Saintes-Maries, 1888
65 x 71 cm
Oil on canvas
Rijksmuseum Vincent van Gogh, Amsterdam

The delicate shimmer of the sky, water, and sand were painted in the studio as a contrast to the flat outlined areas of color making up the boats.

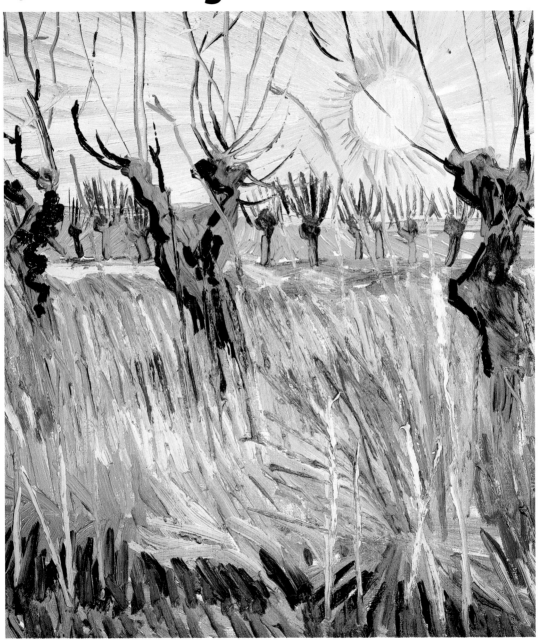

The paintings of 1888 and 1889 constitute van Gogh's most impressive period of creativity. Here in the south of France he believed himself close to achieving his vocation as a painter of peasants and to capturing his admiration for Japanese woodcuts in his own pictures. Arles was his substitute for Japan. The "landscapes in the snow with the white mountain peaks against the sky, gleaming like the snow – that was like the winter landscapes of the Japanese." Provence stood for new subject matter, and above all for a "stronger sun" and "a different light." His subject matter was views of Arles and its surroundings, preferably in full sunlight or at different times of the day. He spent whole summer days painting in the open, in order to complete the pictures in a single day without major interruptions. He studied light and color effects, and endeavored to capture them on canvas. Direct expression was more important to him than realistic depiction, irrespective of whether it was in representing landscapes, portraits or still lifes of plain objects such as chairs, a table, flowers or just a pair of clogs.

Heinrich Hertz, photo ca. 1889

Self-portrait in front of his easel, 1888

1888 French Minister of War Boulanger openly works to bring down the Republic.

The foundations for the development of radio technology are laid as Heinrich Hertz demonstrates the existence of electromagnetic waves.

Foundation of the Second International by socialist parties.

1888 Van Gogh does mainly landscapes, but many of the Sunflowers also date from this time.

Van Gogh busies himself preparing for the artists' colony in the Yellow House.

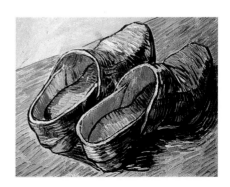

Opposite: **Willows at Sundown**, 1888 (detail)
Oil on card, 31.5 x 34.5 cm
Rijksmuseum Kröller-Müller, Otterlo

Right: **A Pair of Wooden Shoes**, 1888
Oil on canvas, 32.5 x 40.5 cm
Rijksmuseum Vincent van Gogh, Amsterdam

The Light of the South

A longing for bright, colored nature had taken van Gogh south. He declared Provence his Japan; and his view of the Plain of La Crau, one of his finest summer landscapes, as his most Japanese work. He now tried, for example through Pierre Loti's *Madame Chrysanthème*, a travel book about Japan, to learn more about the country itself. Van Gogh particularly valued in the colored Japanese woodcuts the clarity of forms, their light, the precision of line, and their considerable wealth of

Wheat Field with View Towards Arles, 1888
Oil on canvas
73 x 54 cm
Musée Rodin, Paris

In the only portrait-format picture in a series of wheat fields, a solitary couple harvests a flood of grain in vigorous yellow and ocher, against the silhouette of Arles and the railway.

details and colors. He sought to emulate his Asiatic colleagues in the experience of nature.

Ignoring the physical strain, he painted non-stop, preferably in the fields, and stood deliberately in the hot midday summer sun in order to capture the fullness of sunlight – "splendid yellow suns" – and the luminosity of things resulting from it. The high position of the sun prevented overlarge shadows, which he made use of for his unbroken light compositions. He replaced strong local colors, the unchanged inherent colors of objects, with sunny moods. He had already begun in Paris to record subjects with rapid brush-strokes and permeating colors. In Arles, he achieved total mastery of this. Bright colors, those that he did not need to mix on the palette first, were applied to the canvas in sweeps and strokes of differing strength: he articulated them with fine outlines, using complementary colors to achieve impressive contrasts with them.

Van Gogh wanted to go beyond the Impressionists' way of breaking down color and the pointilliste technique of intensifying it scientifically. He wanted his forceful brushstrokes to convey his own excitement. No artist had ever done this so consistently and so effectively. He chose subject matter that suited his technique. No atmospheric veiling could suit his occasionally ecstatic use of

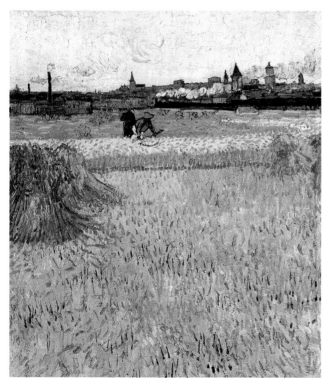

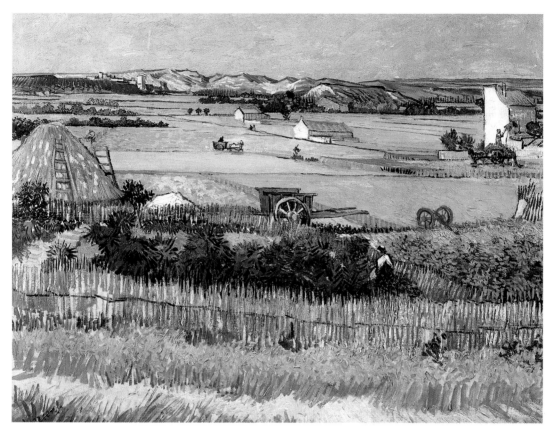

paint, which he sometimes applied thick enough to grasp. He was the first painter to paint the angular beauty of plowed furrows and cornfields. Few artists before him had ventured to capture the flaming ball of the sun in such actuality. The light of the south, in its varying gradations throughout the day as well, was the driving force of his work.

The Plain of La Crau near Arles with Montmajour in the Background, 1888
Oil on canvas
73 x 92 cm
Rijksmuseum Vincent van Gogh, Amsterdam

In this panorama of the plain of La Crau south-east of Arles, a haystack with a ladder and a farmhouse frame the peasants at work. At the focal point stands a huge cart, painted in light violet. *The Harvest*, as

van Gogh called the picture later, is an impressive summer picture in yellow. He was enthused by the effect of the color yellow in the Provençal sunlight, and varied the gradations of yellow from pale sulfurous yellow, lemon yellow, and shades of ocher through orange, refining the application of paint progressively towards the background and

adding contrast with "the most delicate of purples." He structured the expanse of gleaming fields, executed with rapid brushstrokes, with slender contours, green gardens, and a shimmering light violet. The background chain of hills encloses the scene protectively, reinforcing the impression of the peasants' work restricted by the heat of the day.

Van Gogh's Sunflowers

At the end of the 19th century, sunflowers were very popular as decorative cut flowers. They stood for *joie de vivre* and idealism, and were a favorite subject in painting as well. Paintings with sunflowers in them would have been known to van Gogh ever since he studied Flemish baroque painting in Antwerp. In August 1888 alone, van Gogh painted six pictures, several of which he repeated the following January. "Oh this glorious sun here in summer," he wrote to his artist friend Émile Bernard. "I'm thinking of decorating my workshop with half a dozen pictures of sunflowers – a wall decoration on which unmixed and broken chrome yellows will glow on various backgrounds, blue from the palest of Veronese green right through to royal blue, framed in narrow laths painted orangey red." Van Gogh compared the effect of his sunflowers with Gothic church windows.

Twelve to fourteen blooms – rarely fewer – at various stages of growth stand mostly in bulbous vases. The pots are divided into two colored zones, and stand on a narrow ledge that runs to the bottom edge of the picture, while the largely undefined backgrounds press close on the flower arrangements. The *Twelve Sunflowers in a Vase* are painted flat and

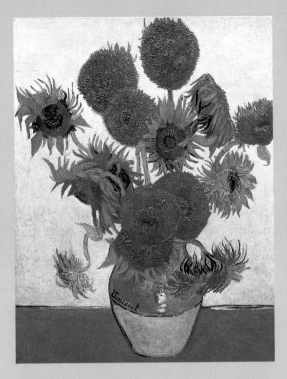

Sunflowers in a vase, 1888
Oil on canvas
95 x 73 cm
National Gallery, London

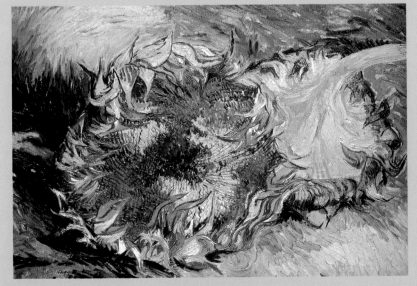

Two Cut Sunflowers, 1887
Oil on canvas
21 x 27 cm
The Metropolitan Museum of Modern Art, New York

He led me into his house in the Place Lamartine, where I saw the wonderful pictures ... Imagine the splendor of these whitewashed walls, on which his colors stood out in all their luminosity!

<div align="right">Paul Signac</div>

pastose. The cool turquoise of the background brings out the glow of the yellow and yellowish-brown tones forcefully. The absence of contrasting shadow intensifies the illusion of summer flowers in Provence. For the variation called *Sunflowers in a Vase*, likewise of 1888, van Gogh repeated the composition. Varying from this basic type, van Gogh also painted several still lifes with already dried and loosely arranged flowers, such as *Two Cut Sunflowers*, for example. These provided less opportunity for ample surfaces, but gave greater scope for his pastose brush technique in the details. Later, van Gogh planned to enclose the picture *La Berceuse, The Lullaby*, a portrait of Augustine Roulin (page 57), between two sunflower pictures to form a triptych.

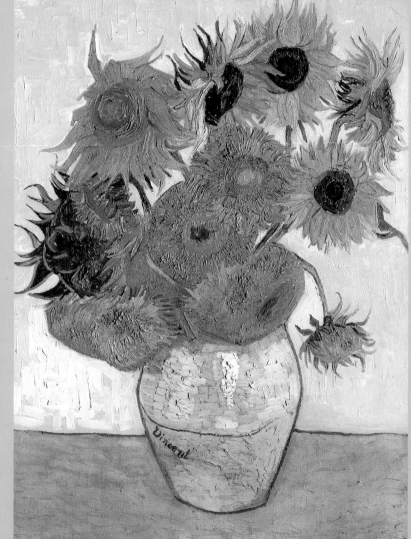

Twelve Sunflowers in a Vase, 1888
Oil on canvas
91 x 72 cm
Neue Pinakothek,
Bayerische
Staatsgemäldesammlung,
Munich

Right:
Joseph Roulin, photo

Below:
Portrait of Joseph Roulin, 1888
Oil on canvas
81.5 x 65.3 cm
Museum of Fine Arts, Boston

The postmaster, a coarse, bearded face, "a real Socrates," sits with legs splayed and slightly facing one side on van Gogh's wicker chair, facing the viewer full frontally.

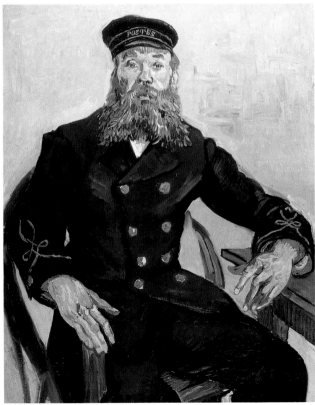

Van Gogh and the Roulin Family

In the first months in Arles, van Gogh neglected portrait painting, presumably from a lack of models. In mid-August, he told Theo about portraits of Patience Escalier and Joseph-Étienne Roulin, the postmaster. Roulin was the freight manager for the local post at Arles station. Van Gogh seems to have become acquainted with him in May 1888 in the course of dispatching a consignment of paintings to Theo. At the end of July, he painted the first of a total of nine portraits.

To Bernard he wrote somewhat contemptuously: "I have done a portrait of a postmaster, actually two, in fact. A Socratic type, and none the less Socratic for being fond of alcohol and consequently high in color. A real subject to paint à la Daumier, eh?" He painted Roulin twice in fact, the second picture in a single sitting: a head and shoulders picture distinguished principally by the sitter's prominent beard and the bright green floral wallpaper. The other portrait is livelier and more generously conceived: the postmaster sits stiffly in front of a pale blue background wearing a Prussian blue uniform trimmed with yellow, his face made up of broken tones of yellow, green, violet, pink, and red.

Van Gogh painted not only the postmaster but, several times over, his wife and their three children also. Further sittings were to improve the

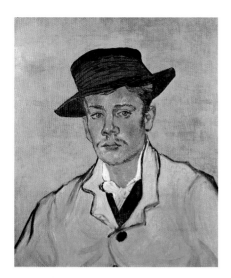

Portrait of Armand Roulin, 1888
Oil on canvas
65 x 54.1 cm
Museum Folkwang, Essen

This head and shoulders portrait depicts the eldest of the three Roulin children, 17-year-old Armand, wearing a hat and yellow jacket against a green background, as a quiet, introverted young man. He later became a peace officer in Tunis and died in 1945 in Nice.

work. He mockingly described the family's appearance to Bernard as "like the Russians." Nonetheless, he made friends with Roulin and his family. He regarded the older man as a fatherly friend who treated him with "quiet seriousness and tender friendship." In January 1889 he had to bid this friend farewell. Roulin had been transferred to Marseilles, but for financial reasons was able to fetch his family only later.

La Berceuse
(Augustine Roulin), 1889
Oil on canvas
93 x 73 cm
Rijksmuseum Kröller-Müller, Otterlo

Van Gogh first painted Roulin's wife Augustine (1851–1930) in December 1888/January 1889. Besides that painting, now in Chicago, there are four other portraits of this strapping woman. On his visits to the Roulin family, van Gogh often saw Augustine sitting in her chair, with the cord in her hand to rock her daughter Marcelle's cradle. La Berceuse, or lullaby, is the picture of a woman sitting in front of a wallpaper with a gay pattern of flowers and tendrils.

The brushstrokes recording the solid shapes of the mother are applied in thick pastose, her arms folded in front of her holding the cradle cord in her rough hands, which are painted lighter than her face. The green jacket and her skirt are outlined with heavy contours against the red of the floor, accentuating the woodcut-style surfaces. The borrowings from his Japanese woodcuts are unmistakable. Van Gogh liked to compare the effect of the picture with simple devotional pictures of the kind often sold as cheap color prints.

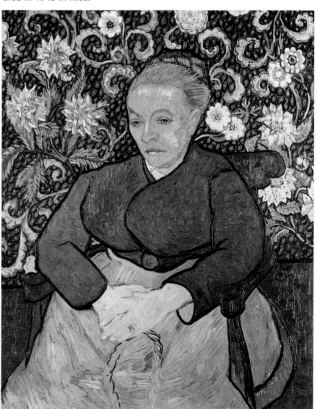

Art and Utopia

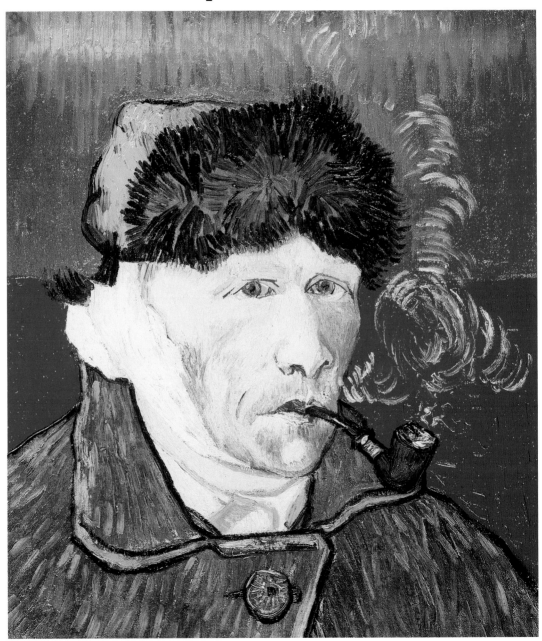

Paul Gauguin's presence in the Yellow House from the fall of 1888 seemed at first to inspire van Gogh. He painted expressive landscapes and still lifes as riots of color, and numerous self-portraits, which he swapped with Gauguin and other artists. However, his idea of an artists' colony in Arles was wrecked by tensions between himself and Gauguin. The violent arguments between him and his artist friend, illnesses scarcely recuperated from, and chronic physical and psychological overtaxing of himself were symptoms of an ominous condition, which reached its climax dramatically in December 1888, when, in a violent fit of rage, the painter cut off one of his ears with a cut-throat razor. He was treated in hospital and then allowed back to the Yellow House. But Gauguin had left, and van Gogh felt himself exposed to intense hostilities from the locals, who wanted to see him shut away for good. In a letter to his brother Theo, van Gogh expressed a wish to enter a closed institution.

The Eiffel Tower, a photo of the time

Self portrait (dedicated to Paul Gauguin), 1888

1888 Unsolved series of murders of London prostitutes – Jack the Ripper is never caught.

1889 Eiffel Tower opens in Paris. Major miners' strike in Bochum spreads to become the biggest industrial action in Germany to date.

1888 In October, Paul Gauguin arrives in Arles and moves in with van Gogh in the Yellow House. The strained relationship between the two painters becomes more and more tense and the situation escalates to the point where van Gogh cuts off part of his ear, prompting Gauguin to leave. Vincent has a serious breakdown and is admitted to a psychiatric hospital.

1889 Vincent voluntarily enters the psychiatric hospital of Saint-Paul-de-Mausole in Saint-Rémy in Provence.

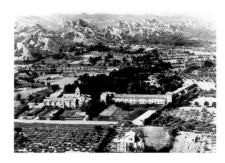

Opposite:
Self-portrait with Bandaged Ear and Pipe,
1889 (detail)
Oil on canvas, 51 x 45 cm
Leigh B Block Collection, Chicago

Right:
Saint-Rémy, St Paul-de-Mausole, photo

An Artistic Community with Gauguin

Paul Gauguin
Jacob Wrestling with the Angel, 1888
Oil on canvas
73 x 92 cm
National Gallery of Scotland, Edinburgh

Vincent van Gogh's idea was to set up an artists' colony in Arles that practised both early Christian and forward-thinking artistic principles. He rented the Yellow House in the place Lamartine to have enough room for this. He and Paul Gauguin, who was his revered friend from his Paris days, were to form the core of the new artistic community. He had invited Gauguin to Arles several times, enthusing to him about the beauty of Provence and offering him the artistic direction of an Atelier du Midi, a Studio of the South. Even Vincent's brother Theo urged Gauguin to consider the idea of living and working in a community in Arles, probably from a fear of Vincent spending his always disastrously depressive winter months alone. An agreement over the money side seems to have made up Gauguin's mind to travel to Provence, as he was living deeply in debt and ill in Pont-Aven in Brittany. Theo wanted to sell Gauguin's pictures through Goupil in Paris and save the money up for the painter to cover a second journey to Martinique and support him in Provence.

At dawn on October 23, 1888, after six months of seesawing

Gauguin painted the picture while still in Pont-Aven, intending it for the church there. A tree diagonally divides the pictorial area in two, compositionally and symbolically. At their devotions in the foreground are several women in Breton dress, shown in profile or with their backs to us facing the subject of the sermon they have just heard, Jacob's struggle with the angel. The confrontation of real and unreal, everyday piety and Old Testament narrative is painted with only a gesture at modeling, with no shadow, and shapes abruptly simplified. By dispensing with incidental details in favor of a conceptual summary, and by using striking complementary colors, the master of abstraction succeeds in creating an early work of Symbolism.

Recollection of the Garden at Etten, 1888
Oil on canvas
73.5 x 92.5 cm
Hermitage, St. Petersburg

Trying out Gauguin's approach of working from memory, van Gogh composed this picture for his bedroom in Arles showing the garden of his parents' house in Etten, with mother and sister amid a colorful array of cabbages, cypresses, and dahlias.

Paul Gauguin
The Woman from Arles (Madame Ginoux), 1888
Charcoal drawing
56 x 48.4 cm
The Fine Arts Museum of San Francisco, San Francisco

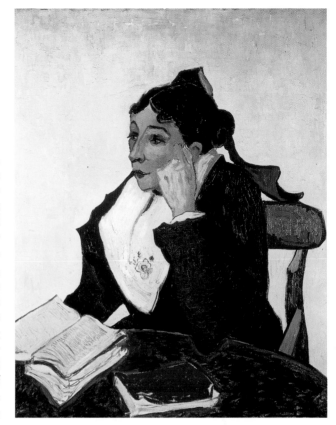

between fear and hope by van Gogh, Gauguin reached Arles. Letters from this period document that the two artists initially settled in well to live and work together. They painted related or identical subject matter such as the woman from Arles, influenced each other's work, talked, went for walks in the day, and to cafés at night. Van Gogh was fired by Gauguin's descriptions of the South Seas, and both of them saw it as the natural future homeland for young artists. Gauguin favored painting from memory, a kind of abstract fantasy painting, in order to shake off the naturalism of the Impressionists. For a while, van Gogh also became interested in painting this way, for example in *Recollection of the Garden at Etten* and *L'Arlesiènne: Madame Ginoux with Books*, but in the end he found the loss of the immediate on-the-spot impression too much of a burden.

Soon tensions developed between the two artists, both in everyday matters and their work together. The extreme intensity of the work, the permanent desire to influence the other, Gauguin's repeated intention to leave early and the strength of character of both all contributed to a change of mood in the Yellow House. Even a joint expedition to the Musée Fabre in Montpellier to see works by Eugène Delacroix and Gustave Courbet was unable to clear the air. Alcohol, quarrels, and finally violence led to drama before Christmas, Gauguin's departure, and the premature end of the artistic community.

L'Arlesiènne: Madame Ginoux with Books, 1888
Oil on canvas
91.5 x 73.7 cm
The Metropolitan Museum of Art, New York

Van Gogh took only an hour to paint this portrait of a woman seated pensively at a table in front of a lemon yellow background. The picture strives for color contrasts and sharp outlines.

Van Gogh's Use of Color

Instead of eating, he paints and works out how much paint consumption gives him.

Bertholt Brecht (1898–1956), writing about van Gogh in his diary, July 8, 1920

Color in art is a basic and unusually adaptable and expressive medium of design that can trigger off specific reactions in the viewer. For van Gogh, paint was a virtuoso and available means of representation whose individual components of application, mixing, and modeling changed radically during his brief career as an artist. Though van Gogh took some interest in art theory during his years of learning, his use of color seems to have been more the result of his own practical experiments and observing the work of old masters and contemporaries, because he was always talking about "struggling to get the right color." An exception was his study of complementary colors in the theory and works of Eugene Delacroix, which increasingly influenced his painting. The juxtaposition of one of the

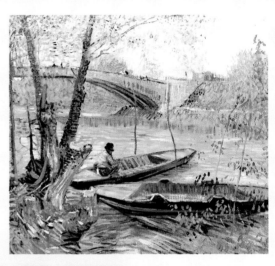

Angler and Boats by the Pont de Clichy, 1887
Oil on canvas
49 x 58 cm
The Art Institute of Chicago, Chicago

three primary colors – red, yellow or blue – and a mixture of the two others creates a particular luminosity and maximum contrast.

A letter to his brother Theo in September 1885 about complementary colors documents van Gogh's knowledge of this color effect even then, but the contrast of pure colors still seemed too bold for his painting in Nuenen. For this

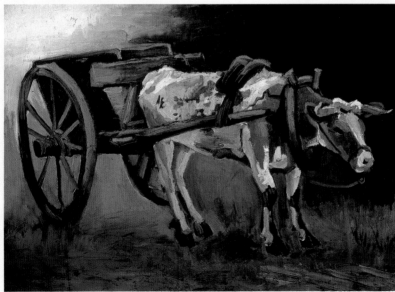

Cart and Reddish-brown Ox, 1885
Oil on canvas on wood
57 x 82 cm
Rijksmuseum Kröller-Müller, Otterlo

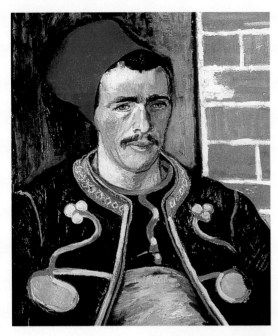

through color combinations. In Arles, on the other hand, he strove for colors that expressed something in their own right. In pictures such as *The Zouave* of 1888, the application of pure colors as unmodeled areas with emphasized contours is typical, and is orientated on Japanese color prints and the work of the Cloisonnists. Finally, in *Olive Trees*, a late work, the brushstrokes are typically short and sharply curved, the result of pure, strong colors being applied quickly and vigorously. He wrote to his brother: "The painter of the future is a colorist such as has not existed before." Van Gogh himself was this colorist.

The Zouave, 1888
Oil on canvas
65 x 54 cm
Rijksmuseum Vincent van Gogh, Amsterdam

epoch in his peasant painting, the use of dark, earthy color mixtures were characteristic, and largely object-oriented. His involvement with Impressionism in Paris meant a huge step forward in van Gogh's art. He combined a predominantly light palette and fragmentation of objects into minute dots and strokes of color that were to come together as a whole only in the eye of the viewer, as in the *Angler and Boats by the Pont de Clichy* of 1887, with the intention of conveying his own impressions

Olive Trees, 1890
Oil on canvas
49 x 63 cm
National Gallery of Scotland, Edinburgh

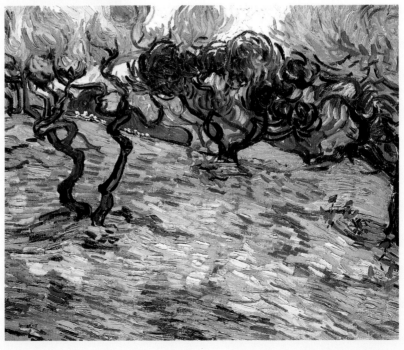

Nocturnal World

In summer 1888, van Gogh painted several night scenes, whereby both the artificial light from the gas lights and the clear night sky interested him. The intimate world of night cafés and brothels and their clientele he had recorded in interior pictures (page 37) where figures and rooms merge in the yellow light of the lamps. Warm summer nights also drew him outside, to capture specific impressions of nature under a blue starlit sky. He set up his easel in the nocturnal place du Forum, in order to paint the terrace of the Grand Café du Forum in the city center. Anonymous, dark figures sit at small round tables under gas lights on the wooden terrace of the café. The artificial light turns the wall into shades ranging from yellow and orange to violet, and shatters on the cobbles in brown and orange tones. The rue du Palais passes the café in the darkness of the background, where only a few windows are dimly lit. The clear night-blue sky ranges over everything as contrast, the stars appearing to explode in it like fireworks.

According to a famous but probably apocryphal anecdote, van Gogh painted at night in the light of numerous candles that he attached to the broad brim of his straw hat. In fact he said he often got colors mixed up, painting outside at night.

The café terrace has its literary counterpart in Guy de Maupassant's novel *Bel-Ami* (1885), at the beginning of which is described a starlit night in Paris with brightly lit boulevard cafés. Van Gogh's view of the nocturnal café scene is good-humored: for him, the night was livelier and richer in colors than the day. Even during his nocturnal painting, his pleasure in work remained undimmed: "it gives me enormous pleasure to paint night on the spot. It used to be that the picture was drawn or painted the day after the drawing. But I enjoy painting the thing directly."

Terrasse des Cafés in the Place du Forum, 1888
Oil on canvas
81 x 65.5 cm
Rijksmuseum Kröller-Müller, Otterlo

The painting, done by van Gogh in the open at night, shows a cheerful scene in the artificial light of terrace lamps beneath a dark blue starlit sky.

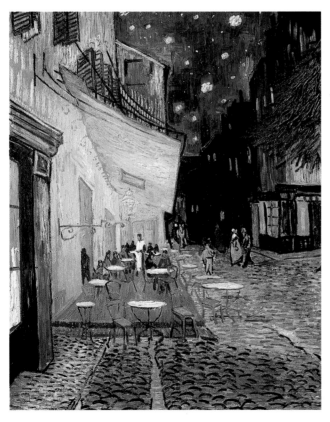

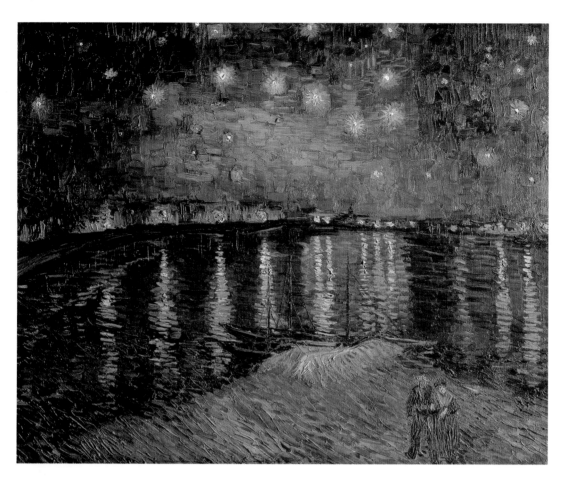

After his return from Saintes-Maries, he expressed in his letters to Theo a desire to paint a starlit sky at last. With the help of a gas lamp, in September 1888 he painted a scene of the night sky seen from the Rhône bank, looking towards Trinquetaille bridge. Broad strips of greenish-blue sky, the distant town in blue and violet, the water royal blue, and a yellowy green meadow in the foreground with a strolling couple make up the landscape-format, nocturnal panorama. The lights of the town are reflected in the water in long successions of ripples, while the sky, particularly the Great Bear, is distributed in shafts of light. Strong, broad brushstrokes offer a rich, contrasting interplay of color.

Starlit Sky over the Rhône, 1888
Oil on canvas
72.5 x 92 cm
Musée d'Orsay, Paris

The lights of the town are reflected in long lines on the Rhône, while stars gleam as pools of light in the night sky: a pattern of yellow and blue as an impression of night.

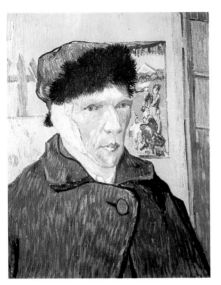

Drama in Arles

The obsessiveness driving Vincent van Gogh in all his activities – whether as a preacher in La Borinage or as an artist – was the same demon as goaded him into a long chain of reckless self-abuse that reached a dramatic climax on December 23, 1888, when he slashed off part of his right ear.

The circumstances of the deed were never fully clarified. Although still present in Arles at the time of the self-mutilation, Gauguin only made mention of it in writing 15 years later. According to Gauguin's version, which obviously "improves" his role in the drama, since November there had been ever more violent discord between the fellow painters who were to lead the Atelier du Midi as an artistic community. Both everyday matters and artistic differences

Self-portrait with Bandaged Ear, 1889
Oil on canvas
60 x 49 cm
Courtauld Institute Gallery, London

The *Self-portrait with Bandaged Ear*, now in London, shows van Gogh wearing a blue, fur-trimmed cap, a thick green jacket and a noticeably pale, apparently strained face after his release from hospital. The bandage on his right ear indicates that the self-mutilation was still recent. The easel in the background and Japanese woodcut on the back wall are attributes of his work and his artistic inspiration.

Bereaved Old Man, 1890
Oil on canvas
81 x 65 cm
Rijksmuseum Kröller-Müller, Otterlo

With delicate and, for him, restrained brushstrokes, van Gogh refrained from all effects of dramatic movement and placed the old man, who presses his fists to his eyes in grief, in the center of the linear structure.

fueled the arguments. As a result, Gauguin had probably decided to leave Arles before the end of the year they had initially planned together, and told Vincent of this. Gauguin also says that, while painting a still life of Vincent's favorite flowers – sunflowers – he had had the notion of painting his fellow artist as he worked at the same time. When van Gogh saw the portrait, he commented: "Yes, that's me, but as a madman" (page 79).

When the two men came to blows later the same evening, Gauguin told him that he would get ready to leave. The following evening, Gauguin heard footsteps behind him in the place Victor-Hugo, and when he turned round, he saw Vincent with a cut-throat razor in his hand. Van Gogh broke off the attack, turned back into the Yellow

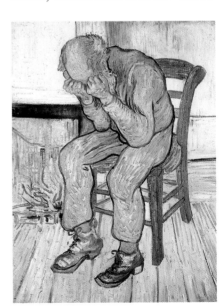

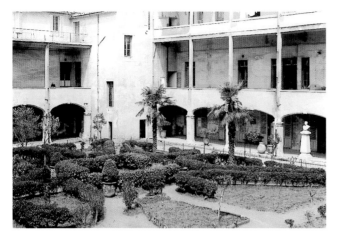

House and cut off part of his right ear. He wrapped it in a cloth and handed it to the prostitute Rachel. Comparisons with matadors, who present the ear of the defeated bull to their women, are surely not fanciful. After his return to the Yellow House, Gauguin was suspected of having killed van Gogh, but, as the injured man was still breathing, Gauguin was released and van Gogh was taken to hospital.

The following day, Gauguin left. Self-punishment to the point of self-mutilation was the result of van Gogh's boundless self-abuse. His solitary life – that included no repose nor even real human closeness – the furious work tempo, inadequate food, illnesses barely recovered from, psychological exhaustion after all the impassioned artistic achievements, perhaps also the reflection of himself as a madman in his colleague's portrait, the failure of his artistic community, and the renewed threat of solitude

The inner court of the hospital in Arles to which van Gogh was admitted, photo

The Garden of the Hospital in Arles, 1889
Oil on canvas
73 x 92 cm
Oskar Reinhart Collection, Winterthur

probably all contributed toward his going beserk.

After two weeks, van Gogh was released from hospital, but many of his neighbors in the place Lamartine no longer wanted him in the vicinity. After repeated hallucinations and a further spell in the clinic, people were afraid of him. A petition was submitted to the mayor demanding his committal to a psychiatric hospital. Vincent asked Theo to arrange the necessary formalities for psychiatric treatment. Indeed, van Gogh's life has contributed in no small degree to the myth that modern artists need to be endowed with a certain degree of insanity.

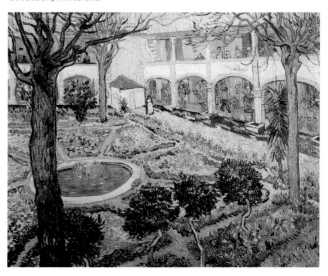

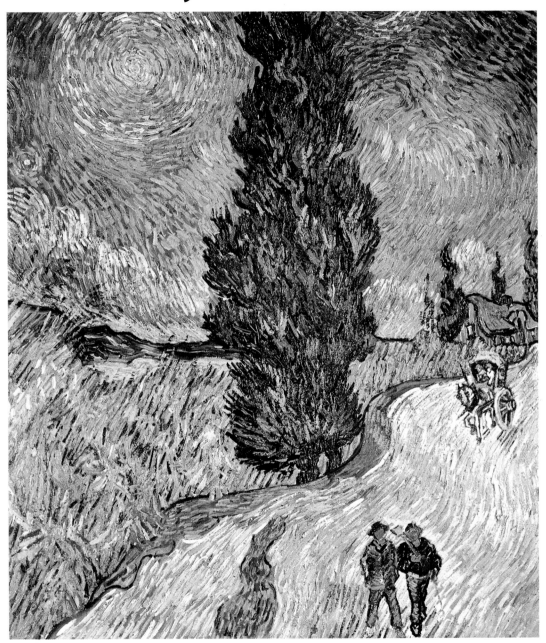

After another breakdown and subsequent visit to the clinic, van Gogh decided to enter a psychiatric hospital voluntarily, and asked his brother Theo to make the necessary arrangements. In May 1889, he left Arles and took himself to the clinic of Saint-Paul-de-Mausole in a former monastery a mile or so from Saint-Rémy-de-Provence. The hospital was managed by a former naval doctor with no specialist qualifications. Vincent was given a small room and a small chamber as a studio. The fits of hallucination returned in Saint-Rémy, and van Gogh's vague hopes of a speedy recovery were dashed. Despite being locked up, he plunged into painting again. Under supervision, he took short walks to explore the new landscape, and recorded its cypresses and olive trees in pictures. Lacking subjects, he painted from reproductions, copied his own works, recorded the interior of the institution and its barren views, and painted several self-portraits.

Otto von Bismarck, photo 1889

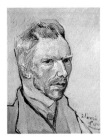

Self-portrait, 1889

1889 Expulsion of French Minister of War Boulanger from France.

Bismarck introduces social welfare legislation in Germany.

Brazil abolishes slavery and declares a republic.

Bertha von Sutten publishes the key work of pacifism: the novel *Die Waffen nieder* (*Lay down your arms*).

1889 While in the psychiatric hospital of Saint-Rémy, van Gogh copies his own pictures and old masters from reproductions, which his brother Theo sends him from Paris.

Opposite: **Country Lane with Cypresses and Star**, 1889 (detail)
Oil on canvas, 93.3 x 74 cm
Rijksmuseum Kröller-Müller, Otterlo

Right: **Starlit Night (Cypresses and Village)**, 1889
Pen, 47 x 62.5 cm
Kunsthalle Bremen, Bremen

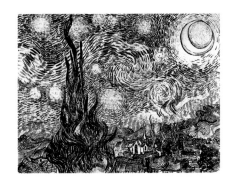

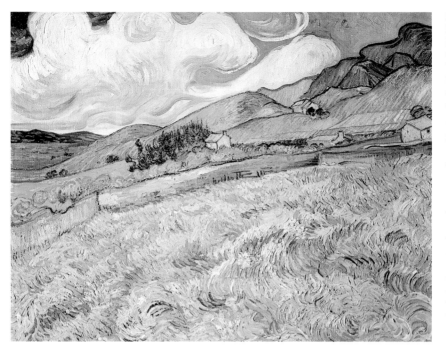

Mountain landscape behind Saint-Paul Hospital, 1889
Oil on canvas
70.5 x 88.5 cm
Ny Carlsberg Glyptothek, Copenhagen

Between Arles and St. Rémy about 16 miles away lies the Alpilles mountain range, one of the loveliest of their kind in Provence. The fragmented and yet sublime landscape with cypresses and olive trees forms the background of van Gogh's picture of an enclosed wheat field that he could see from his institutional cell. The diverse greens of the wheat field and mountain meadows and the huge clouds against a blue sky above the bluish-purple hilltops of the Alpilles indicate late spring. Short, parallel sweeps of the brush create an effect of motion in the field in the foreground.
In July, he wrote to his brother about working on another picture of the "cornfield with a small reaper and large sun," which was dominated by summery yellow.

Painting in the Face of Despair

Soon after the first fit, van Gogh experienced a second attack, which obliged him to return to the hospital. Fearful that his situation would get worse, the "red-haired madman," as he was now known in Arles, decided to enter a psychiatric hospital of his own accord. On May 8, he went with the parish priest Salles to the hospital of St-Paul-de-Mausole, which occupied a former monastery a mile or so from Saint-Rémy-de-Provence. He wrote to Theo that he did not regret the voluntary incarceration in this prison, but his hopes of recovery were quickly dashed. Fur-

View from the institution over the enclosed field, photo

Van Gogh's outlook from his cell was toward the east through a barred window like a perspective frame on to the former monastery garden, where only wheat was cultivated during his time there. He recorded the field in several pictures.

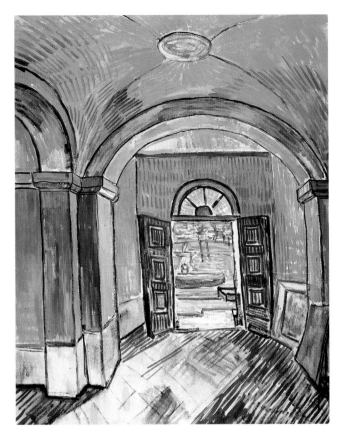

Entrance hall of the monastic building: institutional grilles, photo

The photo of the hall reveals the solid grille that lends the place the character of a prison, although the open front door suggests the freedom to leave. Van Gogh left the bars out of his otherwise realistically oriented painting.

ther attacks of hallucinations and aural delusions were, in his own words, the consequence of "external influences." Van Gogh tried to use work as therapy. He had been allocated a small room on the ground floor, which he soon began using as a studio. He painted long institutional corridors, massive iron window bars and subjects in the immediate environment, a senior guard, irises in a vase, a fountain in the park or views from the barred windows. In letters to Theo he described the dreary surroundings, his solitude, and finally

Entrance Hall of Saint-Paul Hospital, 1889
Crayon and gouache
61.5 x 47 cm
Rijksmuseum Vincent van Gogh, Amsterdam

In October, van Gogh painted the hall in a rather graphic style, emphasizing outlines and hatching, that contrast the light and dark parts of the interior.

the melancholic certainty that Saint-Rémy could not cure him. He was afraid of a new attack rendering him incapable of work. For fear that he would no longer be able to supply paintings in return for Theo's financial support, he stepped up his painting, and wrote: "I slaved away like a madman. I have a grim determination to work like never before."

Artistic Traditions

Throughout van Gogh's years as an artist, the influence of other artists on him is unmistakable, but there were short periods in particular when he concentrated on copying. After a while, he turned to copying subjects and styles from versions of black-and-white printed reproductions. In early summer 1889 he explained in a letter to his brother Theo why he was working from reproductions of other artists: "I place the black-and-white of Delacroix or Millet or black-and-white reproductions from their works in front of me as subject matter. And then I improvise color on that, but don't get me wrong – I'm not wholly myself, but try to

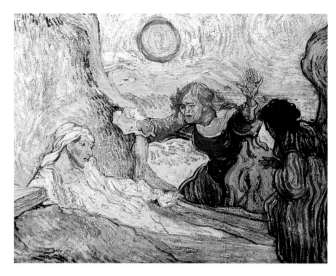

The Raising of Lazarus (after Rembrandt), 1890
Oil on paper
50 x 65 cm
Rijksmuseum Vincent van Gogh, Amsterdam

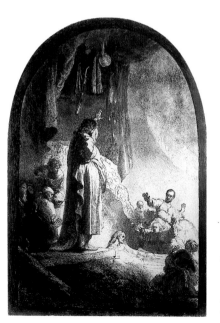

Rembrandt van Rijn
The Great Awakening of Lazarus, ca. 1632
Etching and burin
36.6 x 25.8 cm
Rijksprentenkabinett, Amsterdam

Rembrandt's etching is not a reproduction of a painting but designed as a printed graphic. Van Gogh took over only a section of it, with Lazarus awakening and frightened, gesticulating figures.

record recollections of their pictures – but this recollection, the approximate correlation of colors that I comprehend through feeling, even if they are not the right ones – that is my own interpretation."

With the word "recollection" van Gogh was in part alluding to the "painting from memory" he tried out with Gauguin (page 60). Van Gogh did numerous works both appreciating and – through his reinterpretation – competing with old masters; 36 such paraphrases are preserved from his Saint-Rémy period alone. In the psychiatric hospital, it was the lack of models and subjects that drove him to work from engravings and etchings of pictures of Honoré Daumier and Jean-François Millet, for example. In Saint-Rémy, two artists were particularly important – Rembrandt and Eugène Delacroix. The former, the most important Dutch painter of

The Good Samaritan (after Delacroix), 1890
Oil on canvas
73 x 60 cm
Rijksmuseum Kröller-Müller, Otterlo

Van Gogh's quest for greater intensity of color was a clear break with Impressionism and at the same time a stylistic step forward, drawing on the color theories of Delacroix. Van Gogh blended Delacroix's typical red and blue tones with earthy brown and yellow tones to create a living rhythm of cold and warm in contrast with light and dark colors in expressively varied brushstrokes. The religious subject matter matched his lonely and wretched situation, but was not a renewed religious mania. "I particularly like in Delacroix that you can feel the life of things, and the expression and movement that he imposes on top of the technical skill," wrote van Gogh, commenting on his preference for the French painter.

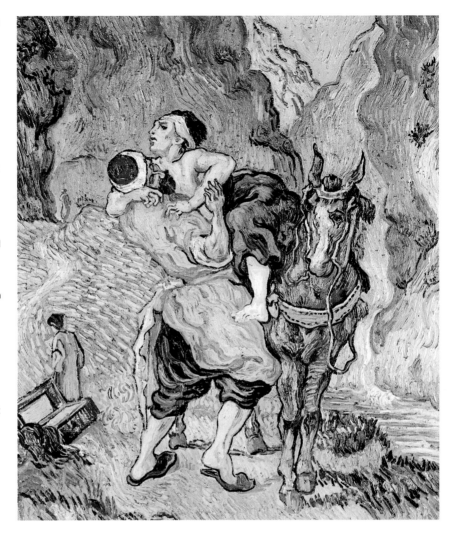

the 17th century, was inspirational above all because of his figures and his picture structures. According to van Gogh, Rembrandt painted from his powers of imagination; he actually felt the subjects. Delacroix meanwhile, the early 19th century French painter, influenced van Gogh's drawing style and use of color. The use of color as a medium of expression was an achievement of Delacroix's to which van Gogh devoted himself increasingly.

The Sower, after Millet

Van Gogh returned to the subject of the sower several times. Anyone who has ever observed a peasant farmer sowing will be fascinated by the peculiar rhythm of this outdoor work. One hand holds the mass of seed, the other scatters it in large, rapid, sweeping gestures that must be harmonized with the forward movements, so that an ideal density of corn grows later. Van Gogh's first *Sower*, a pen and wash drawing from 1881, captures the typical movement: an arm reaching up to throw, and a striding step. But the drawing was not a specific study from nature but a copy of Jean-François Millet's drawing of 1865 (p. 18), which had been reproduced as an engraving. The clothing and movement of the figure and the very high horizon of the field with the farmer harrowing as the sun goes down are all taken from Millet's composition. In Arles in 1888, van Gogh did several more versions. Initially these too were derived from Millet, but the individual interpretation is much more evident. They concentrate on the relationship between the small figure and the extensive field, and the painting technique, tending toward flat color and dark outlines as in the *Sower* sold by Christie's, may be attributed to van Gogh himself. Likewise, from the hand of the interpreter is the strong contrast in the use of color by emphasizing complementary colors in thick paint applied with rapid, dynamic sweeps of the brush.

Around November 21, 1888, he sent Theo a sketch from another *Sower* picture. Whereas in the earlier compositions the naturalistic figures tended to be rather incidental, here the simplified figure of the

The Sower, 1881
Pen and wash, highlighted with green and white
48 x 36.5 cm
Rijksmuseum Vincent van Gogh, Amsterdam

sower moves into the near foreground. Beside him, van Gogh places the silhouette of a dark, leaning tree that divides the picture diagonally. The peasant, the tree, and a huge orb representing the sun on the horizon form an effective trinity of large shapes, against which the details of the distant town and bark of the tree seem filigree and anecdotal. The bold composition with the stylized visual shapes, the dramatic intersections and triangular encapsulations of the fields, together with the highly expressive, pastose application of paint, are surprisingly modern for 1888. Despite the coarse

The Sower, 1888
Oil on canvas
33 x 40 cm
Christie's Images, London

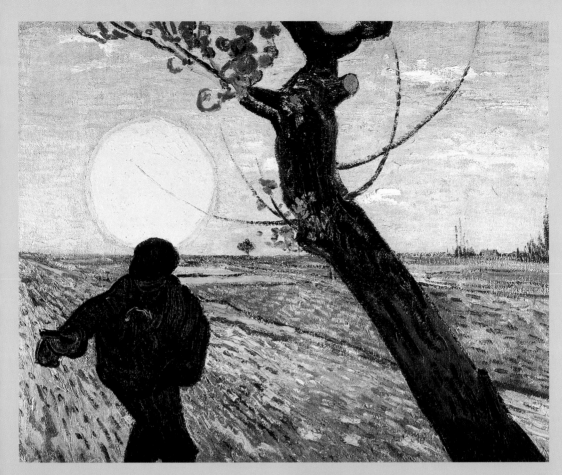

choice of shape and color, the painter succeeded in capturing sensitive impressions, for example when the peasant holds his seed carefully like a child and strews the corn almost tenderly with his large hand. This last version van Gogh considered to be his most successful representation of a sower. He has also clearly moved on from Millet's example.

Above:
The Sower at Sunset, 1888
Oil on canvas
32 x 40 cm
Rijksmuseum Vincent van Gogh, Amsterdam

Right:
The Sower, 1888
Oil on canvas
72 x 91.5 cm
Privately owned

A Search for Meaning in Nature

Van Gogh was initially not allowed to leave the grounds of the Saint-Rémy institution. For the time being, he therefore did reworkings of reproductions, also some still lifes, a few portraits and views onto a field enclosed by the former monastery wall. Nature, and experiences of nature, consisted in the meantime only of cultivated ornamental and utilitarian plants within the hospital site which he used for pictures, like the portrait-format painting of an iris. However, he was soon allowed to go on short outings accompanied by an attendant in order to explore the landscape of his new environment. The blossoming orchards of Arles turned into the olive groves of Saint-Rémy, partly populated with harvesting peasants.

The twisting, gnarled olive trees were depicted by van Gogh with short, curved brushstrokes, consolidated into tree trunks by heavy outlines. Van Gogh's rapid technique

Wheat Field with Cypresses, 1889
Oil on canvas
52 x 65 cm
Privately owned

In this picture, van Gogh displays no interest in the realistic documentation of nature but investigates the qualities and motion of individual plants, which he expresses impressively by his choice of color and technique.

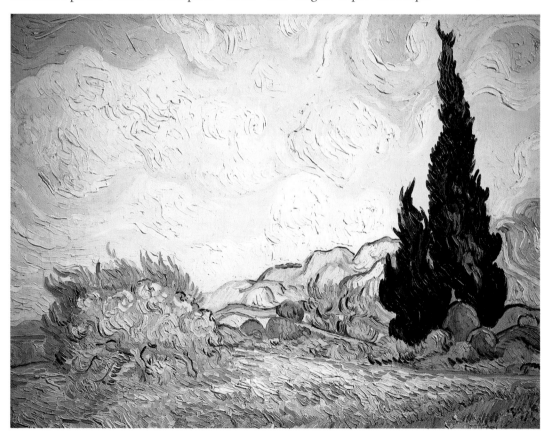

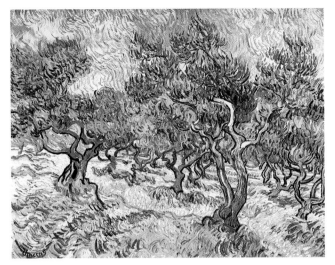

blended the individual features into the picture of an olive grove, whose odd shapes must have been created by the mistral. Yellow and green brushstrokes for the meadow evolved into trees, and higher up developed into branches and foliage of rich green against a blue sky. The power-ful luminosity of color that he had developed in Arles reappears in the 15 or so surviving pictures of olive trees from this period. Expansive landscapes with cornfields rimmed with hedges, where the blazing out-lines of dark cypresses writhe heaven-wards, constitute another area of subject matter for his hunger to express the experience of nature. He structured the numerous landscapes such as his *Wheat Field with Cypresses* with varied palettes and brush techniques. Individual techni-cal elements such as dots, strokes, reliefs or contoured surfaces were no longer used exclusively to represent

Olive Grove, 1889
Oil on canvas
72 x 92 cm
Rijksmuseum Kröller-Müller, Otterlo

Iris, 1889
Oil on paper on canvas
62.2 x 48.3 cm
National Gallery of Canada, Ottawa

Among a jumble of serpentine leaves with dark contours rise narrow, stiff stalks with a few purple flowers and some buds indicated only by their outlines. Van Gogh painted this picture of a wild iris in a green meadow in May 1889.

individual objects, for example as wheat ears, but reproduced visual correlations that van Gogh himself had also experienced while painting: thus corn and motion became the gentle rocking of a cornfield. In addition, his nature scenes from Saint-Rémy display a particular vehemence of color, which he was able to vary by applying different accents in paint.

As so often in earlier years, he sought to escape his attacks, the soli-tude, indeed the wretchedness of his situation, by the intoxication of hard work. In Saint-Rémy this meant above all his impressions of nature: concentrated lines of color served as a medium to express his own state of mind.

Looking at Himself

A special type of portrait painting is the self-portrait, a very ambitious art form in that the painter is also the client, sitter, and viewer. Even in the earliest days of portrait painting, artists attempted to record their gaze in the mirror. The attention the subject devotes to the later viewer of the painting, concerns in the first instance the gazer himself. Direct communication, leaping off the canvas, is thus a feature of self-portraits. Van Gogh frequently directed his gaze at himself to record it on canvas, and yet, apart from some early photos, we do not have any clear picture of the artist. Self-portraits are subject to the same stylistic treatment as the rest of the

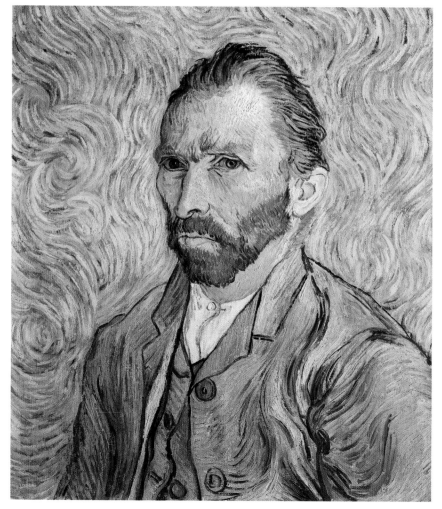

Self-portrait, 1889
Oil on canvas
65 x 54 cm
Musée d'Orsay, Paris

In his penultimate self-portrait in September 1889, van Gogh contrasted the light brown tones of the face and vigorous reddish-brown of the hair with the light-blue of the suit and background. He slowly intensified the movement of the streaks of paint from the white of the shirt outwards over the suit and head to the violent spirals of the back wall. The tribulations and strains of his recent life can be read in his face. Nevertheless, he wrote to his brother Theo that "with great effort" he had painted himself "very calm." In contrast with some of the self-portraits after his great crisis, he shows here his unimpaired left aspect. The well-crafted structure and verisimilitude of his memorable facial features, which are endowed with the dramatic ornamentation of rhythmically intensifying brushstrokes, are characteristics of the best portrait painting.

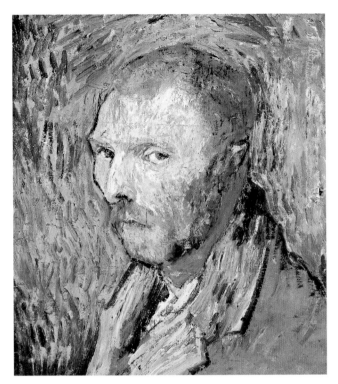

Paul Gauguin
**Van Gogh Painting
Sunflowers**, 1889
(detail)
Oil on canvas
73 x 92 cm
Stedelijk Museum,
Amsterdam

When van Gogh was painting his favorite sunflowers in Arles, Gauguin had the idea of painting a portrait of him at work. The portrait shows van Gogh hard at work in front of his easel. The facial features are coarse, and the subject holds an exaggeratedly small brush in his large hand. Recognizing himself as "a madman" was a shocking experience for van Gogh, and was certainly a contributory factor in his attack on Gauguin the same evening and the self-mutilation.

Self-portrait, 1889
Oil on canvas
51 x 45 cm
Nasjonalgalleriet,
Oslo

This self-portrait dates from September 1889, and shows him afflicted by grave crisis and depression. Facial features and clothing are only roughly rendered in pastose, rapidly executed brushstrokes. A heavy contour separates the face from the flowing movement of color constituting the background.

artist's oeuvre, that is an artist like van Gogh, who set scarcely any store by naturalistic pictures of people or objects but was determined to render an impression of the unique situation, would hardly adopt visual realism for his own portrait. "Anyway, I'd love to know what I'm the larva of," he wrote to Émile Bernard. The driving force of the portraits was the constantly renewed searching gaze at himself in very different versions. All the pictures, therefore, vary widely.

But apart from self-examination, there were other reasons for van Gogh to do self-portraits. Swapping portraits with friends was to create the basis of a collection and repre-sent their presence in the Atelier du Midi. Portraits for the family tended to display a brave face in times of crisis, because they were intended to reassure the recipients; and finally, no one else being available, the artist was his own model.

What Makes a van Gogh?

Composition

Van Gogh liked to break up pictorial areas into horizontal strips or large triangles, which he combined partly with heavy perspective lines. To enhance the effect of depth, he often steers the viewer's gaze in the traditional way by placing a dark object in the left foreground, to which are attached a broad open space and, centrally in the center ground, the principal object. For preference, the horizon is high. Part of van Gogh's armory in a well-planned composition are the perspective qualities of certain color combinations, which can, for example, reinforce or reduce the effect of depth.

Houses in Auvers, 1890
Oil on canvas
75 x 62 cm
Museum of Fine Arts, Boston
(bequest of John T. Spaulding)

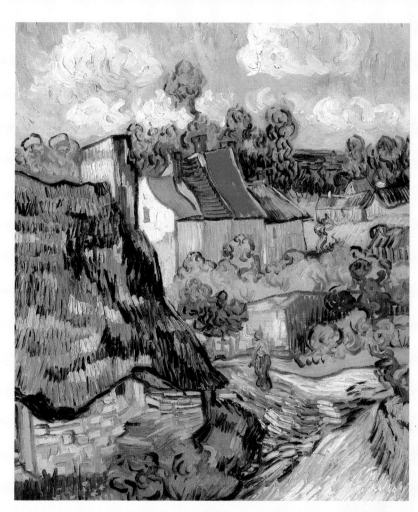

Application of paint

The principal feature of van Gogh's pictures is a vigorous, almost relief-like application of pure colors, which are varied from time to time in rapidly applied dots, strokes, and flat surfaces expressing vitality and movement.

Contours

Van Gogh uses outlines to bring together the predominantly small quantities of paint in a brushstroke into specific pictorial shapes or to demarcate large contiguous areas of color. Mostly dark, the contours generate contrasting and dynamic effects in the pictorial structure.

Coloration

Van Gogh's pure colors do not reflect the real-life model but convey the particular impressions of the moment. The coloration he uses often produces complementary contrasts, and always homes in on the direct effect.

Auvers-sur-Oise

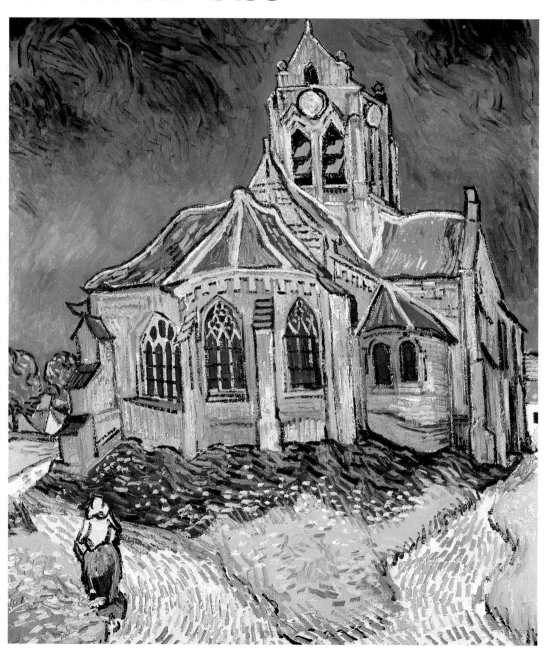

Auvers-sur-Oise was planned as Vincent van Gogh's future residence, because there he could be in the care of a doctor and only an hour from Paris. The world of art was slowly becoming aware of his work – the January issue of *Mercure de France* contained a well-disposed article by Albert Aurier. Van Gogh exhibited at the Salon des Vingtistes in Brussels in February 1890 and there sold his painting *The Red Vineyard*.

On May 17, he left the hospital in Saint-Rémy and traveled to Paris for a brief visit before going to Auvers. The day after his arrival, he threw himself into his work again, and painted portraits, views of towns, and nature with impressive vigor and intensity of color, completing approximately 80 paintings and 60 drawings in little over two months. At the end of July 1890, in "boundless loneliness" he shot himself with a revolver and died two days later in the presence of his brother.

First statistical counting machine

1890 Hollerieth invents the first machine to do statistical counts. It is successfully used in a census in the USA.

May 1 is declared International Labour Day.

London's trams are electrified.

Oscar Wilde's novel *The Picture of Dorian Gray* triggers a storm of protest in strait-laced Victorian England.

Bismarck retires as Imperial Chancellor after 19 years.

The US cavalry massacres 200 Sioux Indians at Wounded Knee, ending the wars against the Indians. Henceforth, almost all Indians live in reserves.

Theo van Gogh, photo, 1890

1890 Van Gogh is discharged from Saint-Rémy psychiatric hospital at his own request.

He moves to Auvers-sur-Oise, where he makes friends with Dr. Gachet, a doctor who was well-known in Parisian art circles and was an amateur artist. Vincent learns to etch from him.

In the afternoon of July 27, van Gogh shoots himself, dying of his serious injuries two days later in the presence of Theo, who had come down from Paris.

1891 Seven months after his brother, Theo van Gogh, also dies.

Opposite:
The Church at Auvers, 1890 (detail)
Oil on canvas
94 x 74 cm
Musée d'Orsay, Paris

Right:
Dr. Gachet, 1890
Etching, 18 x 15 cm
Kunsthalle Bremen, Bremen

Henri de Toulouse-Lautrec
Marie Dihau at the Piano, 1890 (detail)
Oil on card
55 x 30 cm
Musée Toulouse-Lautrec, Albi

Marguerite Gachet at the Piano, 1890
Oil on canvas
102.6 x 50 cm
Öffentliche Kunstsammlung, Kunstmuseum, Basel

For this picture of Marguerite Gachet at her music, van Gogh used a narrow portrait format reminiscent both of kakemonos (Japanese roll pictures) and female portraits of The Hague School. The absence of depth in the pointilliste, half-light, half-dark back wall, against which the light, glowing figure turns into a single musical line, makes the comparable picture by Toulouse-Lautrec seem dark and conservative.

In Dr. Gachet's Care

Vincent van Gogh first mentioned to his brother Theo that he wanted to leave the psychiatric hospital in Saint-Rémy in September 1889 and perhaps move in with his avuncular friend, the painter Camille Pissarro. When the latter's wife objected, Pissarro recommended Auvers-sur-Oise, a place where Vincent could live under the watchful eye of a medical man, Dr. Gachet. Being only an hour by train to Paris, he would be nearer his brother, who had mean-

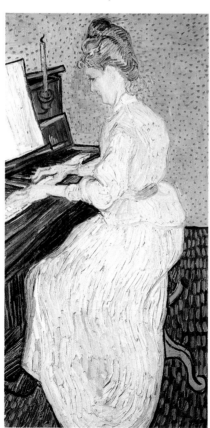

while married and become father of little Vincent Willem.

On May 17, 1890, van Gogh left Saint-Rémy for Paris, spent a few days with Theo, and then set off for Auvers-sur-Oise. The room that Dr. Gachet had recommended to him was conveniently near his own house, but unfortunately too expensive for his patient. Van Gogh rented a small, cheap room in the Ravoux inn opposite the Town Hall, with the idea of renting a spacious house later.

The artist soon got in touch with Dr. Gachet, a medical man who also liked art and was himself an amateur artist, and who had had Paul Cézanne, Camille Pissarro, and other artists to stay in his house and owned pictures by them. Unfortunately, like Dr. Peyron in Saint-Rémy, he could offer no specialist medical expertise that could have benefited van Gogh. His practice in Paris took up only a few days a week. Auvers was reserved exclusively for his artistic passions. One may assume that Gachet's initial willingness to take on van Gogh was that he would after all be hobnobbing with an artist recommended by Pissarro.

At first, contact was limited to Sunday lunch with Dr. Gachet. Their discussions of their mutual love of art, Gachet's commission for a portrait and his wish to see Vincent's pictures, soon generated a friendly relationship between the two men. Van Gogh described his portrait painting of this period as a search for passionate expression with the help

Dr. Paul-Ferdinand Gachet, photographed at the age of 62

According to Vincent, the 62-year-old heart specialist Gachet was at least as mentally disturbed as van Gogh himself, a melancholy man who suffered from his work. Van Gogh paid for his treatment with paintings, which were mostly ordered from the doctor as copies of Vincent's older works.

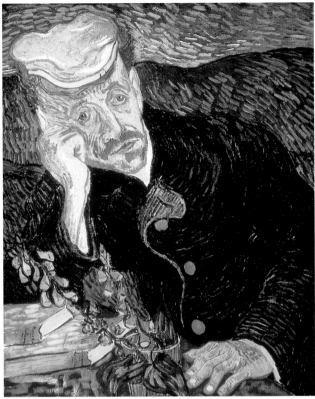

of color but without any pretension to photographic similarity. Beside the doctor, who was a widower, the house was home to his 17-year-old son and a daughter of 20 or so, Marguerite, whom van Gogh likewise painted several times. The best-known portrait shows Marguerite at her favorite occupation, which was playing the piano.

Van Gogh's last pictures are mostly landscapes: cornfields, whose autonomous brushstrokes scarcely represent ears of corn or sky any more but dynamic rhythms of vigorous color energy, or broad, relief-like planes of

Portrait of Dr. Gachet, 1890
Oil on canvas
67 x 56 cm
Private collection

Van Gogh painted his new friend the melancholy doctor in the traditional pose of a melancholic. The pale face and yellow books contrast against the blue background, whose brushstrokes reinforce the inclination of the figure.

color made up of short brushstrokes that articulate and move and are overarched by dominant stormy skies painted in virtuoso variations of dark blue. Landscapes like this he sent to Paris with the "reassuring" news that he saw in them something "healthy and invigorating."

Existence and Late Fame

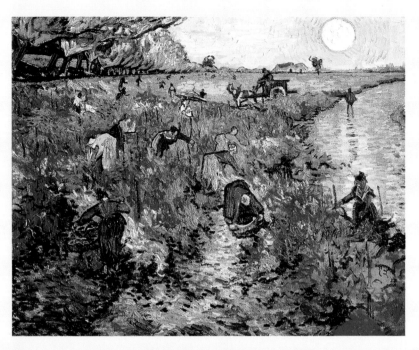

Existence

The Red Vineyard, 1888
Oil on canvas
75 x 93 cm
Pushkin Museum, Moscow

Vincent's upkeep was paid for by his brother Theo, the art dealer, for the whole of his life as an artist. The two had agreed that Vincent would pay for the monthly remittances with pictures, which would perhaps later be sold. Despite Theo's marriage and the birth of a child, Vincent expected the 150 francs a month, which he received in three installments, to continue even after he moved to Auvers-sur-Oise. As he ordered paint direct from

Theo, his brother's money was enough for food and accommodation in the inn. Although in Auvers he surpassed even his previous level of production – on average, he painted more than one work a day – he soon realized that he had not made it as a successful artist. "Leaving aside all ambition," he wrote to Theo and his wife Jo, "I won't get out of practice." He concluded with a bitter forecast: "The outlook seems overcast; no way do

I foresee a happy future for me."

The first hesitant signs of success for his work, the sale of *The Red Vineyard* for 400 francs at the Vingtistes' exhibition in Brussels, a positive article by Albert Aurier in the *Mercure de France,* and forthcoming exchanges of pictures with artist friends flattered the artist. At the same time, such public attention ran counter to his desire to be left alone to work, far from the snobbish studios in the metropolis of Paris.

Van Gogh was caught in a permanent dilemma, on the one hand suffering from never being able to offset his debt to his brother by selling pictures, and on the other hand voluntarily holding aloof from the art market, and this dichotomy became even more pronounced in Auvers. The absence of artistic success seems at least largely a consequence of the failure to put across his own artistic personality with self-assurance. Van Gogh was perhaps the prototype of the unsuccessful artist, whose oeuvre achieves a general breakthrough among connoisseurs, and thus is granted financial reward only after his death.

Late fame

Although Vincent van Gogh worked as an artist for only ten years, of which six must be regarded as years of apprenticeship, he is today one of the most popular artists of all time. His fame is based partly on his unusual life, which lives up to many of the current clichés about artists and was governed by a continual search for an ideal way of life. In his own lifetime, van Gogh sold only one picture – *The Red Vineyard* of 1890. He saw the ideal artist as a producer of pictures which should not remain reserved for an elite public in expensive exhibitions but which – in the awareness of a social obligation – should serve as a basis for reproductions that "would bring some light into the houses of the poor." The dilemma of van Gogh's life as an artist – his quest for recognition and the socialist demand for an art for all – was resolved only after his death. Nowadays, his works – such as his *Fourteen Sunflowers in a Vase* – fetch ever larger record sums in the auction rooms of the world, and many households contain simple color postcards of his works.

Most expensive works

Portrait of Dr. Gachet,
auctioned in 1990
for $75m

Self-portrait,
auctioned in 1998
for $71m

Iris,
auctioned in 1987
for $49m

Sunflowers,
auctioned in 1995
for $36.23m

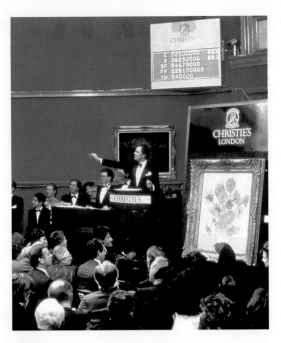

Above:
Auction of the *Fourteen Sunflowers* at Christie's, London, March 30, 1987, photo

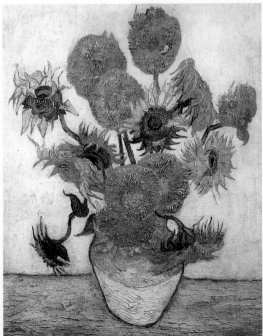

Left:
Fourteen Sunflowers in a Vase, 1889
Oil on canvas
100.5 x 76.5 cm
Yasuda Fire & Marine Insurance Company, Tokyo

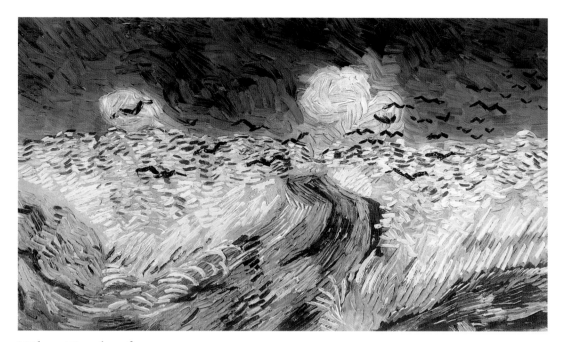

The End of a Lonely Life

The closeness of family was not something van Gogh experienced in Auvers to the extent he had clearly hoped. Although he continued to correspond with his brother Theo – and visited him and was indeed visited by him, his wife Jo, and little Vincent, to whom the painter enjoyed showing the animals in the country – the relationship seems to have been strained. Individual letters display, for example, worried or aggressive questions about further financial support. The possibility that he was no longer as secure as he had been was shattering for Vincent. He also wanted Theo and his family to spend the holidays with him in the country, but they preferred Holland.

Dr. Gachet had led van Gogh to assume that his suffering was overcome and he need only work hard at his painting in order to cure the drastic consequences of the southern sun. Further attacks were not to be expected. Vincent sought a way out of all this by immolating himself in the fury of work. At the beginning of July 1890, he became aware of the deceptive quiescence of his illness and wrote to Theo that he could hardly look forward to continuous good health and didn't know "how things might turn out with me." He poured his desolation and loneliness into landscape pictures such as the *Wheat Field with Ravens*. Finally, he saw no purpose even in his painting

Wheat Field with Ravens, 1890
Oil on canvas
50.5 x 103 cm
Rijksmuseum Vincent van Gogh, Amsterdam

Separate brushstrokes are aligned without outlines to make a highly expressive picture. Heaven and earth move together, and despite their contrasting colors, the black ravens in this picture hold together this picture of desolation and utter loneliness. Seldom does landscape become so clearly a symbolic medium for van Gogh.

any more, and complained he was too old to learn another profession. He even toyed with the idea of entering the Foreign Legion. "If I didn't have your friendship," he wrote to Theo, "it would get so I'd commit suicide without a pang of remorse, and cowardly though I am, in the end I would really do it."

Sensing another attack imminent, on July 27, 1890 Vincent van Gogh pointed a gun at himself, and on July 29 he died. Theo was there at the end, and died seven months after his brother.

Dr. Gachet, **Vincent on his Deathbed**
Auvers-sur-Oise, July 29, 1890
Oil on canvas
24 x 22.5 cm
Musée d'Orsay, Paris

The local paper *L'Écho Pontoisien* of August 7, 1890 reported in its local news: "On Sunday July 27, a certain van Gogh, a Dutch subject and art painter, … inflicted a revolver shot on himself out in the fields; as he was only injured, he returned to his room, where he died two days later." With a few strokes of charcoal, Dr. Paul Gachet, doctor and amateur artist, recorded the facial features of the dead Vincent in rigor mortis, choosing the left, uninjured side of his face for the last portrait of the painter. It looks oddly alien compared with the self-portraits. The picture is dated and entitled *Vincent on his Deathbed*.

Village street and steps in Auvers,
1890
Oil on canvas
49.8 x 70.1 cm
The Saint Louis Art Museum, St. Louis

Van Gogh's view of Auvers displays a symmetrical structure and balance made up of distinct brushstrokes, sweeping lines and outlined areas of color. Among his last works, this painting is astonishing in its hesitant cheerfulness in light colors. The emphasis on restless diagonals generates relaxed movement.

After van Gogh

What we see is an all-embracing, wild, blinding glow; matter, the whole of nature in crazy convolutions, in a raging frenzy, intensified to the point of utmost agitation; it is form become a nightmare, color become flame and lava and precious stone; it is light become conflagration; it is life, burning fever.

Albert Aurier on Vincent van Gogh, in the *Mercure de France*, 1890

Numerous exhibitions after van Gogh's death offered the rising generation of painters a chance to see this painter of the Modern at first hand. Probably the most famous van Gogh retrospective of the period took place in the Galerie Bernheim Jeune in Paris in 1901, influencing many who, in France and Germany in particular, later went on to become distinguished artists. It is astonishing how many different artists and styles equally bore the unmistakable mark of van Gogh's influence, even though the young painters to some extent worked in very diverse styles. In France, the Fauvistes were especially impressed by van

Ernst Ludwig Kirchner
Berlin Street Scene, 1913 (detail)
Oil on canvas
121 x 95 cm
Brücke Museum, Berlin

Gogh. They painted with pure, vigorous colors in scarcely controllable designs that could end up totally deforming the subject, and they were resolute in pursuit of the expressively simplified line. The major personality of the Fauvistes was Henri Matisse who, with Maurice Vlaminck and André Derain,

Henri Matisse
Music, 1910 (detail)
Oil on canvas
260 x 398 cm
Hermitage, St. Petersburg

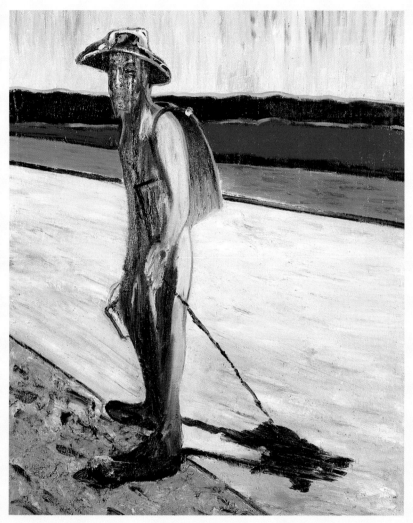

The Painter on his Way to Work, 1888
Oil on canvas
48 x 44 cm
Burnt during the Second World War (formerly in Kaiser Friedrich Museum)

Francis Bacon
Study for a Portrait of van Gogh, V, 1957 (detail)
Oil and sand on canvas
Hirshhorn Museum and Sculpture Garden, Smithsonian Institution (gift of Joseph H. Hirshhorn Foundation 1966), Washington DC

self-portrait *The Painter on his Way to Work* as various views of the figure in the straw hat and box of painting gear.

Van Gogh painted his imposing oeuvre mainly in seclusion and solitude, yet his search for artistic expression beyond the mere reflection of nature found a response in artists time and again. Modern art, it could be said, dates back to his painting.

disseminated a style of painting that, like van Gogh, contained color independently of the object, as an impression of (for example) light and space. Parallel to the French Fauvistes, a group of German artists in Dresden, including Ernst Ludwig Kirchner, Karl Schmidt-Rottluff, and Erich Heckel, came together as the Expressionist group Die Brücke (The Bridge). The art of erupting emotion, the search for the elemental in color and brushstroke, deformation as a revelation of the object and passion of concept are the stylistic criteria that were more than hinted at in van Gogh. The vitality of van Gogh's pictures extends far beyond the artists that succeeded him directly. Francis Bacon, who painted several paraphrases of specific works by van Gogh, produced, for example, a seven-part series interpreting van Gogh's lost

Glossary

avant-garde French for 'vanguard'. Term for artistic groups or artistic statements that are in advance of their time, go beyond what already exists and anticipate trends.

burin A pointed engraving tool held in the palm of the hand.

Cloisonnism Style of painting associated with Paul Gauguin, Louis Anquetin, and Émile Bernard, characterized by the use of areas of bright, unmodeled color enclosed in dark contours, in the manner of *cloisonné* enamel work.

complementary colors Colors opposite each other in a color circle (circular arrangement of the prime colors red-yellow-blue and their mixed proportions) whose common color values complement each other and which together form white or black, according to the mixing proportions, such as red-green, yellow-violet, or blue-orange.

contour Outline of a shape either drawn as a line or shown by means of contrast.

contrast Marked differentiation. In painting, distinction is made between contrasts of light and dark color, warm and cold, complementary or simultaneous.

color perspective A tool for depicting perspective that creates three-dimensionality and depth by the different spatial effect of cold and warm colors. Blue in the background indicates depth, red and yellow emphasize the foreground of a picture.

drawing Preparation for a painting or sculpture, that can also be an independent work of art. Considered to be a direct transfer of an artistic idea into a visual medium.

etching Gravure technique like the principle of engraving but simpler to handle, as the printing plates are made of softer metal.

Expressionism Early 20th-century German style of painting and drawing, less important for sculpture; a counter-reaction to the Impressionist view of art, already questioned in the late 1880s, and a reaction to naturalism and academicism. Its advocates sought to spiritualize and objectivize while avoiding the faithful reproduction of reality.

Fauvism [Fr: *fauves* meaning wild animals] Loosely associated group of artists that developed around Matisse in 1905 in opposition to the Impressionists' dissection of color. They used pure, unbroken colors in their

pictures, ignoring the accuracy of depiction. From 1900, André Derain and Maurice de Vlaminck, working from the basis of van Gogh's painting, developed the principle of strong coloration combined with simple composition. The most important representative of the style, which gave way to Cubism in 1907, was Henri Matisse.

genre painting Paintings depicting typical scenes and events from everyday life, or a particular occupation or social class.

Impressionism Developed around 1870 from the open-air painting (as opposed to studio painting) of the Barbizon School. The name came from Claude Monet's painting *Impression – Soleil Levant* exhibited in 1874. The Impressionists' principal concern was to reproduce an object or landscape in the momentary effect of natural light. To achieve this, color was broken into its individual components and contours were dissolved. Impressionism gained the upper hand over conventional art created solely in the studio.

japonisme Refers to the influence of Japanese art on the Impressionists and later styles such as *art nouveau*. An emphasis on line, the flat echeloning of individual pictorial surfaces,

and an intensive coloration are the main features of this style.

landscape painting Representation of pure landscapes. Though initially landscape was an accessory for filling in background, by the end of the 16th century it had developed into an independent genre. The 17th century created the 'ideal' landscape (e.g. Claude Lorrain's transfigured landscapes) and 'heroic' landscape (e.g. N. Poussin). Landscape painting reached its apogee in the Dutch baroque. Revolutionized in 19th century by the emergence of open-air (*plein air*) painting.

life class Drawing class for art students using a live nude model.

oeuvre The total output of an artist.

oil painting Paint medium in which the paint pigments (pulverized colors) are bound with oil. Oil paint is malleable, dries slowly and can be easily worked into (mixed with) other oil paints. Oil painting emerged in the 15th century, and has since been the dominant medium of painting.

open-air painting (Fr. *plein air*) Paintings done in the open, i.e. direct from nature, rather than in the studio as in academic painting. Plein-air painting was first practiced by the Barbizon

School, then elevated to an essential technique by the Impressionists.

palette Painter's [hand-held] board, usually oval or kidney-shaped, on which paints are mixed. In a figurative sense, it refers to the range of colors used by an artist.

perspective [Lat. *perspicere* meaning penetrate by looking] Representation of objects, people, and spaces on a pictorial surface, as a result of which an impression of spatial depth is created by graphic and painterly means.

perspective lines Imaginary lines running from the foreground to the vanishing point in a picture constructed with a central perspective.

Plein-air See open-air painting.

pointillisme Late 19th-century style developed in France. The Impressionist technique of applying pure color contiguously, in order to create the required color optically at a distance in the eye of the viewer, was elevated to a supreme principle by Georges Seurat (1859-1891) and consistently developed by him, using unbroken colors juxtaposed highly schematically as dots or commas. The new style, called *Divisionism* by Seurat, was first revealed to the public at the Salon des Indépendants in 1884.

self-portrait A picture of an artist by the same artist.

still-life Genre of painting in which lifeless things such as fruit, dead animals, flowers of everyday objects are depicted. Still lifes often have symbolic character. They flourished particularly in Dutch painting in the 17th century. In the 18th century, still-life was catagorized as a 'lower' genre in the academic hierarchy of art. The genre was rediscovered by the Impressionists, though their interest was not in presenting the illusion of an object but in the search for the color and picturesque quality of apparently unimportant objects.

triptych Three-part painting with a fixed center part and folding wings. Usually refers to medieval winged altars.

wash drawing A drawing done with a brush and diluted ink or water color. A *pen and wash* includes lines.

watercolor Water-soluble colors that dry transparent, i.e. they do not cover what is underneath, and are therefore delicate and easy to work with.

Index

Chronology images

Page 7, top left
Julia M. Cameron
Charles Darwin
Portrait photo from ca. 1875

Page 15, top left
Georg Rehlender
Cologne Cathedral
Woodcut, 1880

Page 15, top right
Vincent van Gogh
De Singel in Amsterdam, 1885
Oil on wood, 19 x 25.5 cm
Stichting Collectie P. en N.
de Boer, Amsterdam

Page 27, top right
Vincent van Gogh
Self-portrait, 1887

Oil on canvas
Rijksmuseum Kröller-Müller,
Otterlo

Page 41, top right
Vincent van Gogh
Self-portrait in a Straw Hat,
1887
Oil on canvas on wood
35.5 x 27 cm
The Detroit Institute of Arts,
Detroit

Page 51, top right
Vincent van Gogh
*Self-portrait in Front of his
Easel*, 1888
Oil on canvas
65.5 x 50.5 cm
Rijksmuseum Vincent van
Gogh, Amsterdam

Page 59, top right
Vincent van Gogh
*Self-portrait (dedicated to
Paul Gauguin)*, 1888
Oil on canvas
62 x 52 cm
Fogg Art Museum, Harvard
University, Cambridge (Mass.)

Page 69, top right
Vincent van Gogh
Self-portrait, 1889
Oil on canvas
46 x 38 cm
Christie's, London

Picture credits

The publishers would like to
thank all the museums,
photolibraries and
photographers for allowing
reproduction and their friendly
assistance in the publication of
this book.

© Archiv für Kunst und
Geschichte, Berlin: 4 tr/br/bl, 4
tr, 7 tr, 7 tl (photo: Julia M
Cameron), 8 tl/b, 13 tr/b, 14, 15
tr/tl, 18 r (photo: Erich Lessing),
23 t, 24, 27 tl, 31 r, 34, 38 t, 39 r
(photo: Erich Lessing), 40, 41
tr/tl, 44 t, 49, 50, 51 tl, 54 b, 58,
59 tl, 62 t, 64 (photo: Erich
Lessing), 67 b, 69 tl, 70 t, 75 t, 79
r, 83 tr/tl, 84 t, 85 l, 88, 90 b

© Archivio Fotografico Electa,
Milan: 16 b, 17 t/b, 18 l, 35 b, 36
l, 39 l, 43 b, 47 t, 51 b, 63 t, 71 l,
72 t, 74 t

© 1999 The Art Institute of
Chicago. All rights reserved;
Joseph Winterbothom
Collection, 1954. 326: 5 tl, 26

© Arthothek, Peissenberg: 5 bl,
22, 25 b, 29 t, 33 t, 42, 48 t, 56 b,
57 b, 67 t (photo: Jochen
Remmer), 68, 73, 76, 90 t;
(photos: Peter Willi) 2, 5 br, 32,

78, 82; (photos: Joachim Blauel)
19 t, 55; (photos: Hans Hinz) 29
b, 37, 46, 60 t, 84 b; (photos:
Christie's) 69 tr, 87 t

© The Bridgeman Art Library,
London: 7 b, 8 tr, 15 b, 25 t, 27 tr,
30 b, 44 b, 45 t, 45 b (photo
Peter Willi/BAL), 51 tr, 54 t, 57 t
(photo: Giraudon/BAL), 59 tr
(Fogg Art Museum/bequest
from the collection of Maurice
Wertheim, Class 1906/BAL), 61 r,
63 b, 65 (Lauros-Giraudon/BAL),
66 b, 74 b (Christie's
Images/BAL), 75 b, 85 r, 86

© Christie's Images Ltd 1999,
London: 87 b

© The Fine Arts Museum of San
Francisco; Achenbach
Foundation for Graphic Arts,
memorial gift from Dr. T. Edward
and Tullah Hanley, Bradford
(PA.), 69.30.78: 61 l

© The Solomon R Guggenheim
Foundation, New York;
Thannhauser Collection, gift of
Hilde Thannhauser 1984 (FN
84.3239): 43 t (photo: David
Heald)

© Hirshhorn Museum and
Sculpture Gardens, Smithsonian
Institution, Washington; gift of
the Joseph H. Hirshhorn

Foundation, 1966: 91 l (photo:
Lee Stalsworth)

© Collection Kröller-Müller
Museum, Otterlo: 11, 48 b, 62 b,
77 t

© Kunsthalle, Bremen: 69 b, 83 b

© 1999 by Kunsthaus Zurich.
Alle Rechte vorbehalten: 41 b

© Musée Rodin, Paris: 52

© Musée Toulouse-Lautrec, Albi:
28 b, 38 bl

© 1999 Courtesy Museum of
Fine Arts, Boston. All rights
reserved. Reproduced with
permission: 80, 81 t/c/b

© 1999 The Museum of Modern
Art, New York: 33 b

© Nasjonalgalleriet, Oslo: 79 l
(photo: J Lathion)

© National Gallery of Canada,
Ottawa: 77 b

© Oronoz, Madrid: 30 t

© Rijksmuseum Amsterdam:
72 b

© RMN, Paris: 89 t (photo:
F. Raux)

© The St Louis Art Museum:
89 b

© Scala, Florence: 47 b, 60 b

© Städelsches Kunstinstitut,
Frankfurt: 21 b

© Sterling and Francine Clark
Art Institute, Williamstown (MA):
35 t

© Roger-Viollet, Paris: 27 b, 28 t,
38 br

© Van Gogh Museum,
Amsterdam: 10 t/b, 13 tl, 16 t,
59 b, 66 t, 70 b, 71 r, 91 r;
(Vincent van Gogh Foundation)
4 l, 6, 9, 12, 19 b, 20, 23 b, 31 l,
36 r, 53

© Von der Heydt Museum,
Wuppertal: 21 t

All other illustrations are taken
from the institutions named in
the captions or the publishers'
archives. The publisher has
made every effort to obtain and
compensate copyright
permission for all the works
shown in the illustrations.
Should nonetheless any other
legitimate claims exist, the
persons concerned are asked to
get in touch with the publisher.

Key

r = right l = left
t = top b = bottom
c = center

© VG Bild-Kunst, Bonn, 1999: Émile Bernard
© VG Bild-Kunst, Bonn 1999:Francis Bacon
© Succession H. Matisse/VG Bild-Kunst, Bonn 1999: Henri Matisse
© by Ingeborg & Dr.Wolfgang Henze-Ketterer,Wichtrach/Bern:
Ernst Ludwig Kirchner

© 1999 Könemann Verlagsgesellschaft mbH
Bonner Strasse 126, D-50968 Cologne

Editor: Peter Delius
Series concept: Ludwig Könemann
Art Director: Peter Feierabend
Cover design: Claudio Martinez
Concept, editing and layout: Jana Hyner
Picture research: Jens Tewes, Florence Baret
Reproductions: TIFF Digital Repro GmbH, Dortmund

Original title: Vincent van Gogh

© 2000 for the English edition: Könemann Verlagsgesellschaft mbH

Translation from German: Paul Aston in association with
Goodfellow & Egan
Editing: Susan Fenton in association with Goodfellow & Egan
Typesetting: Goodfellow & Egan
Project management: Jackie Dobbyne for Goodfellow & Egan Publishing
Management, Cambridge, UK
Production: Ursula Schümer
Project coordination: Nadja Bremse

This edition published by Barnes & Noble, Inc.,
by arrangement with Könemann Verlagsgesellschaft mbH

2000 Barnes & Noble Books

M 10 9 8 7 6 5 4 3 2 1

ISBN 0-7607-2158-0

Printing and binding: Sing Cheong Printing Co. Ltd., Hong Kong

Printed in Hong Kong, China